Grimm Fairy Tales

ADULT COLORING BOOK

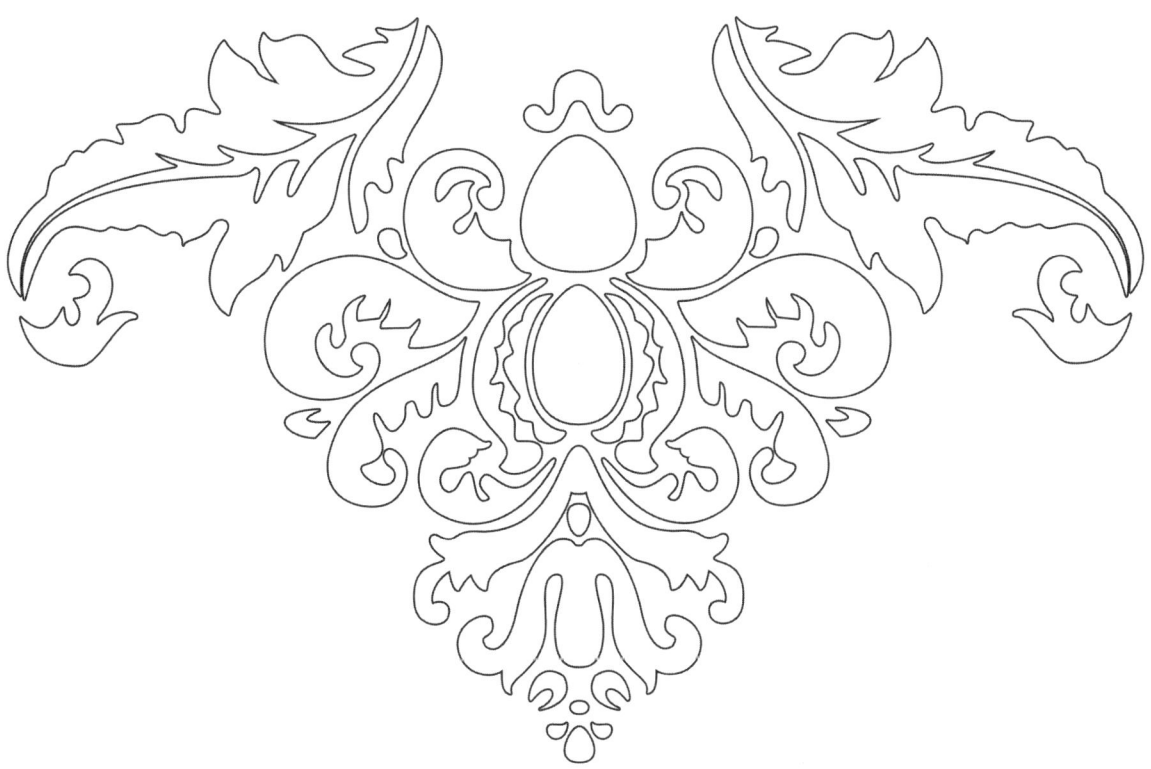

JAMIE TYNDALL

DAWN MCTEIGUE

MIKE KROME

J. SCOTT CAMPBELL

ERIC BASALDUA

ARTWORK BY:

PAOLO PANTALENA

HARVEY TOLIBAO

SEAN CHEN

ROBERTA INGRANATA

PASQUALE QUALANO

DAVID FINCH

WWW.ZENESCOPE.COM

ZENESCOPE ENTERTAINMENT, INC.
Joe Brusha • President & Chief Creative Officer
Ralph Tedesco • Editor-in-Chief
Jennifer Bermel • General Manager
Christopher Cote • Art Director
Jason Condeelis • Direct Market Sales & Customer Service

Grimm Fairy Tales Adult Coloring Book, October, 2015. First Printing. Published by Zenescope Entertainment Inc., 433 Caredean Drive, Ste. C, Horsham, Pennsylvania 19044. Zenescope and its logos are ® and © 2015 Zenescope Entertainment Inc. all rights reserved. Grimm Fairy Tales, its logo and all characters and their likeness are © and ™ 2015 Zenescope Entertainment. Any similarities to persons (living or dead), events, institutions, or locales are purely coincidental. No portion of this publication may be reproduced or transmitted, in any form or by any means, without the expressed written permission of Zenescope Entertainment Inc. except for artwork used for review purposes. Printed in Canada.

FACEBOOK.COM/ZENESCOPE • TWITTER.COM/ZENESCOPE • YOUTUBE.COM/ZENESCOPE

HOW TO USE THE GRIMM FAIRY TALES ADULT COLORING BOOK

STEP ONE
Choose your favorite Zenescope drawing.

STEP TWO
Obtain your color instrument of choice. (crayon, colored pencils and markers will all work)

STEP THREE
Start coloring! Remember to let your mind wander and resist the urge to look at the clock or start a load of laundry. There will be time for that later.

STEP FOUR
Have fun!

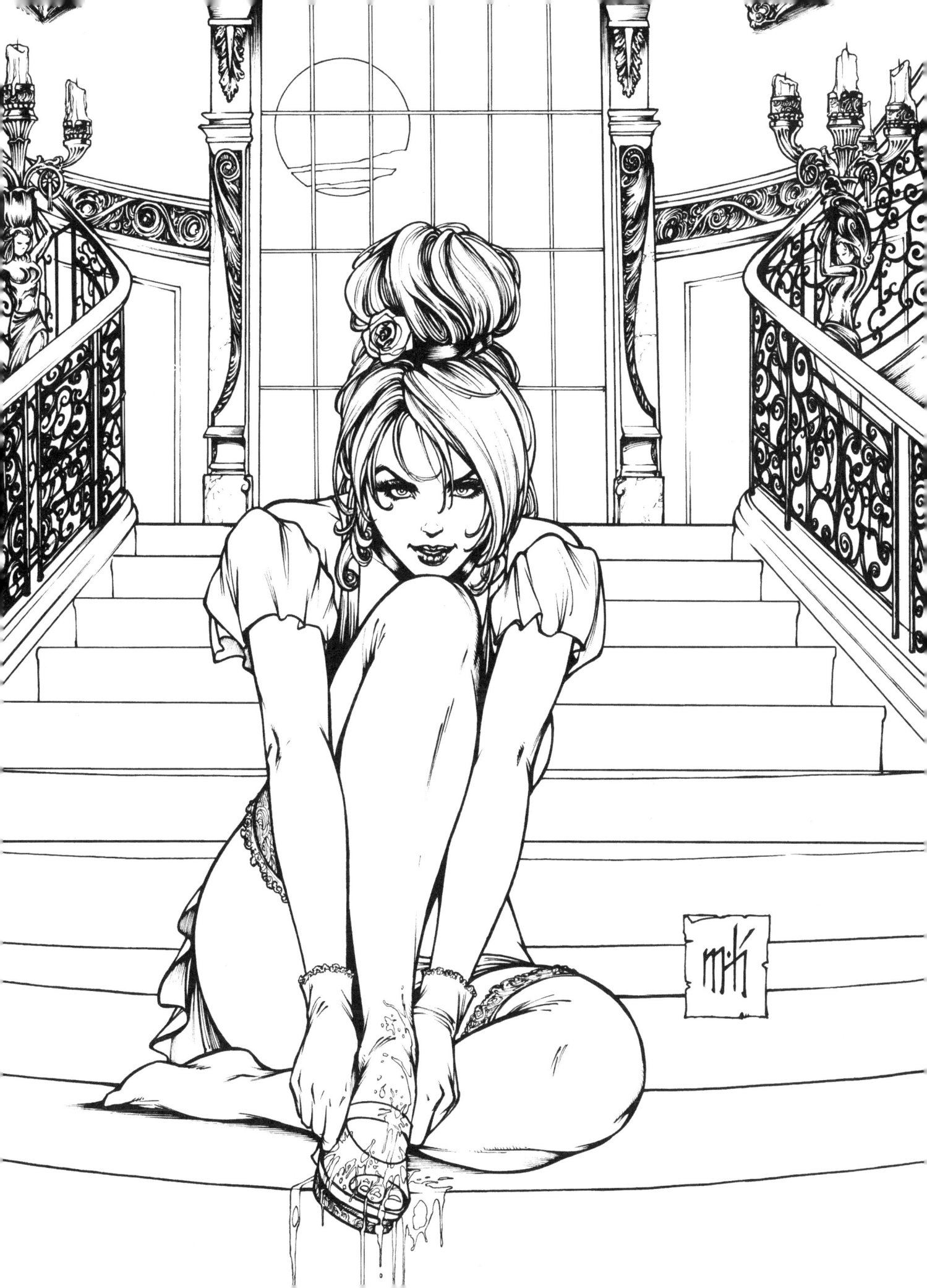

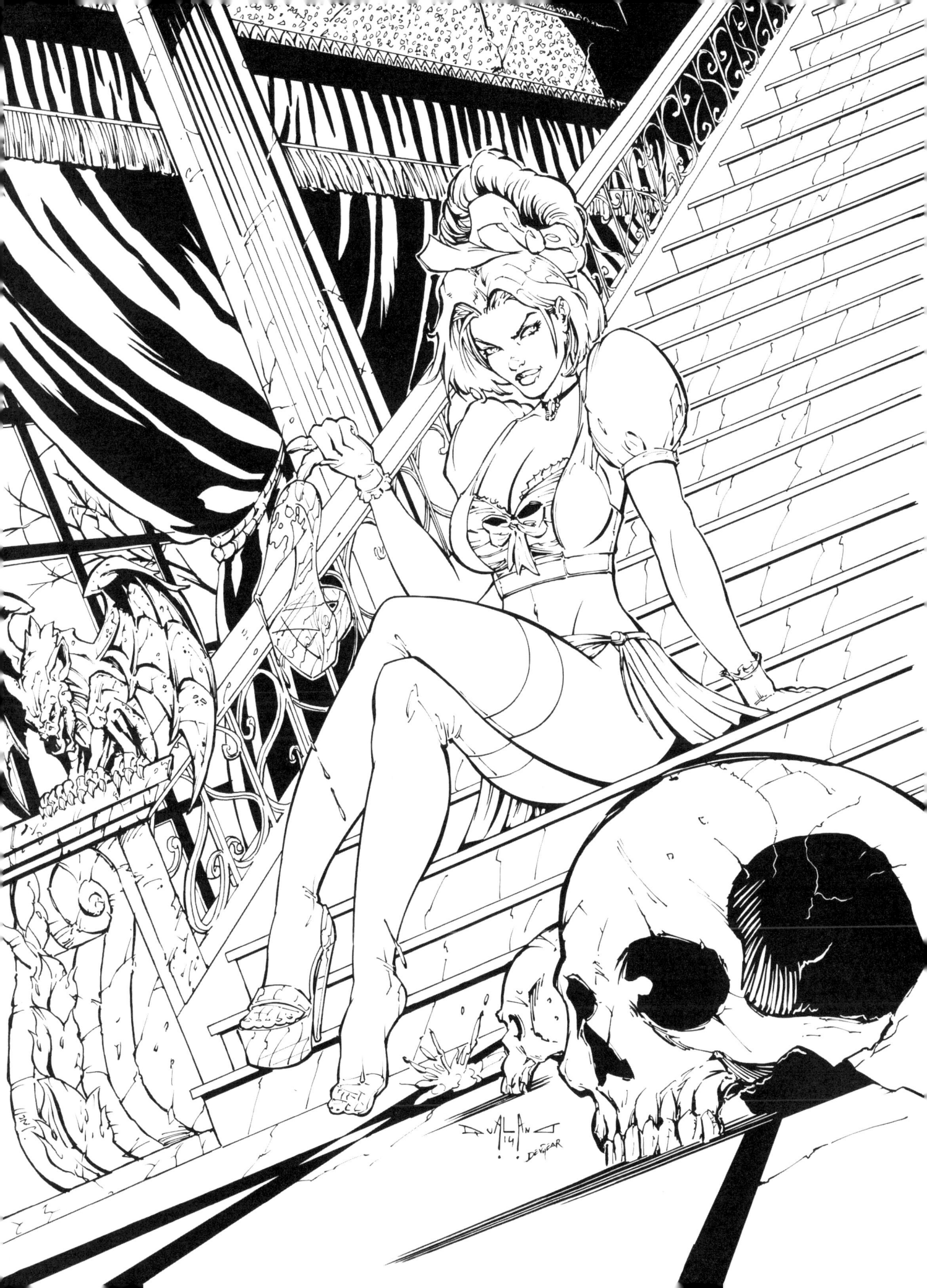

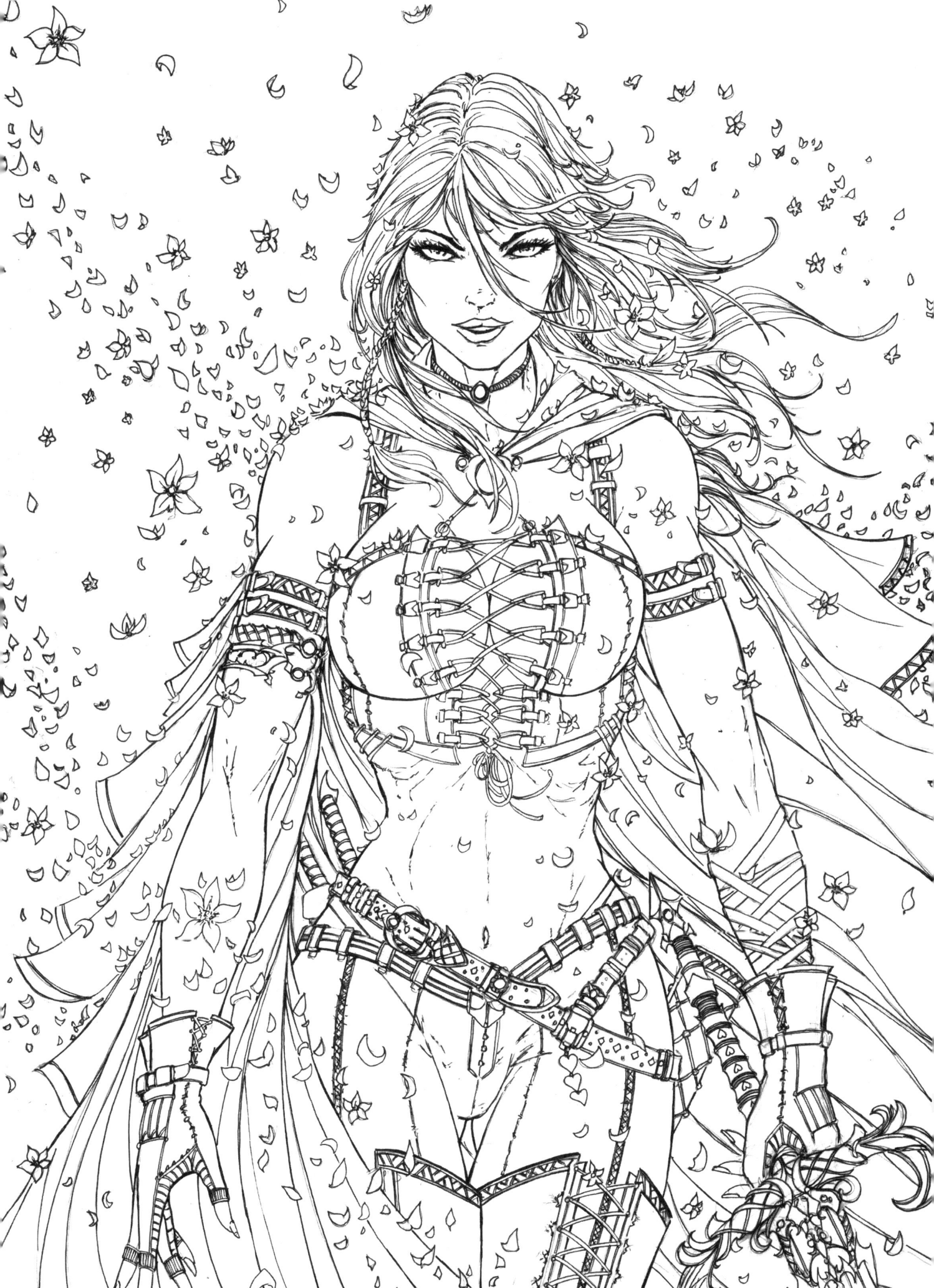

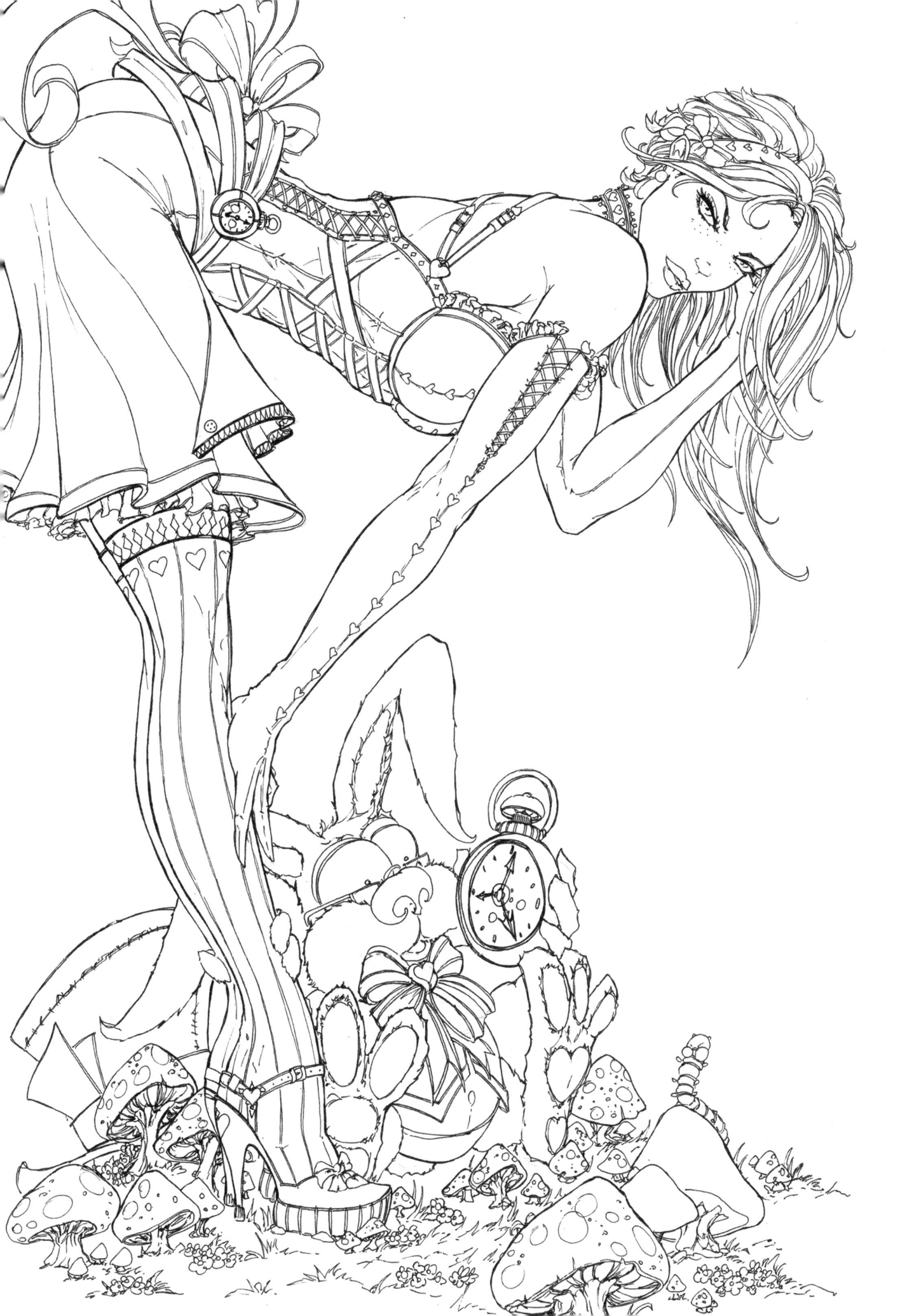

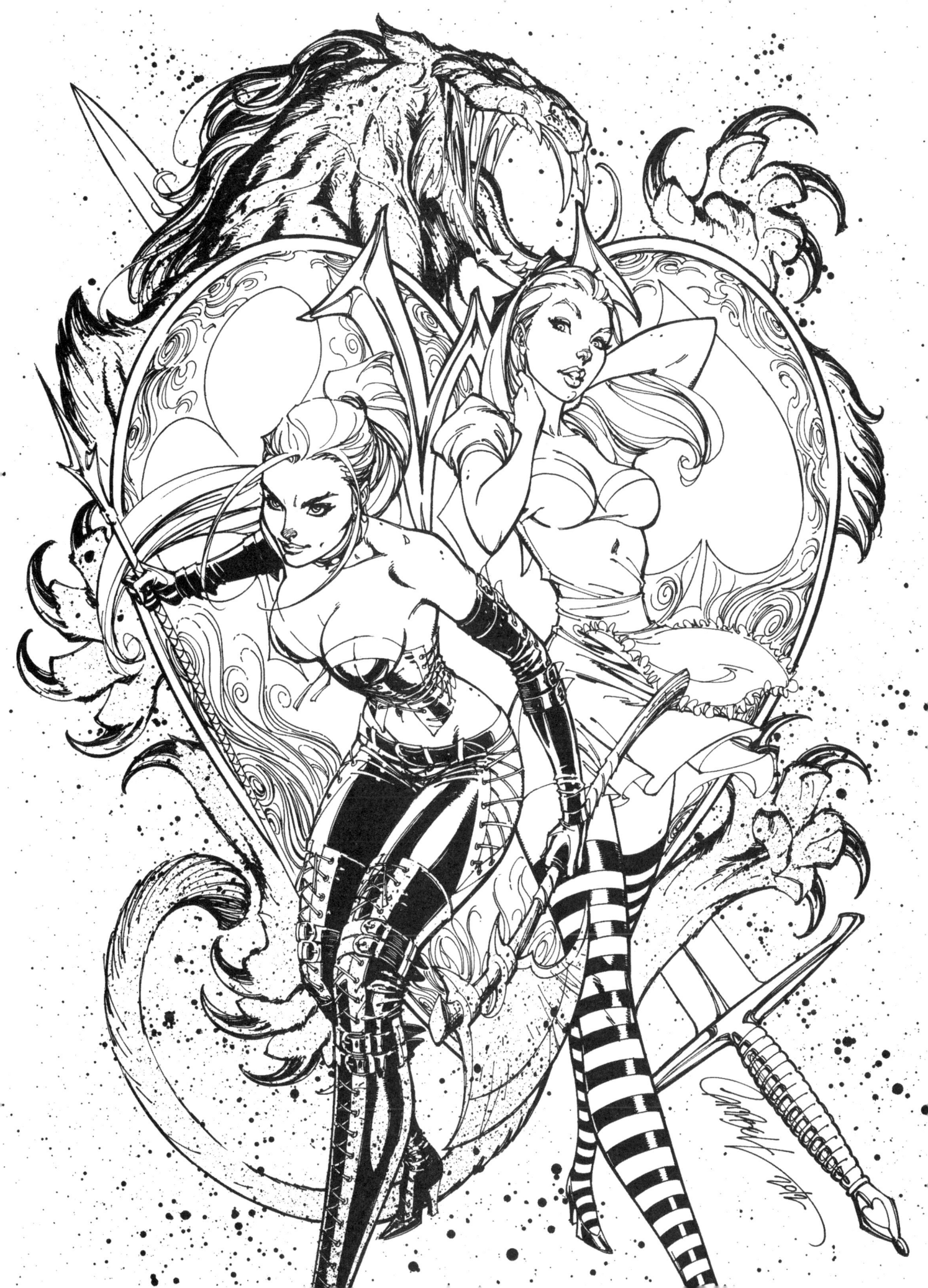

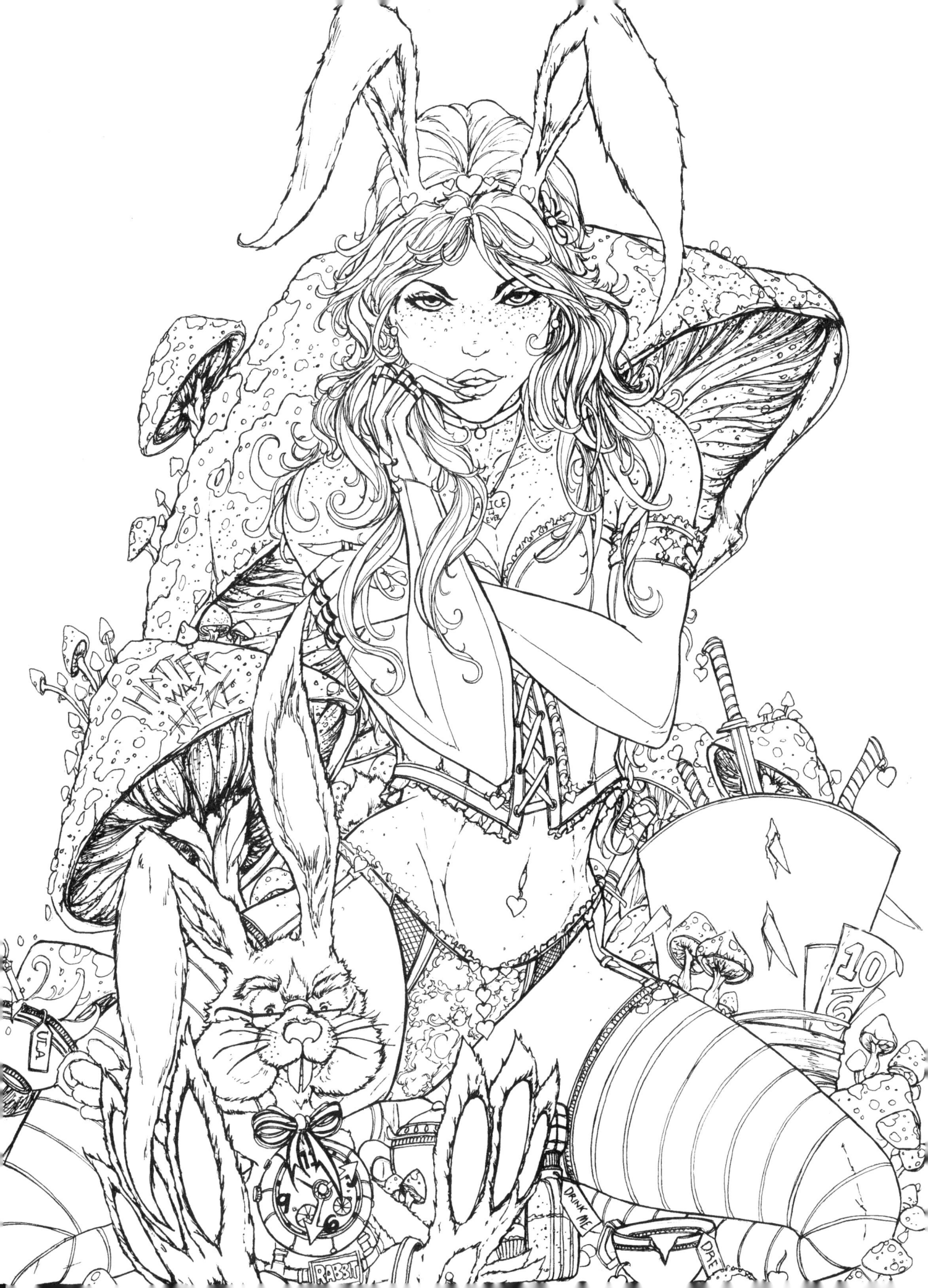

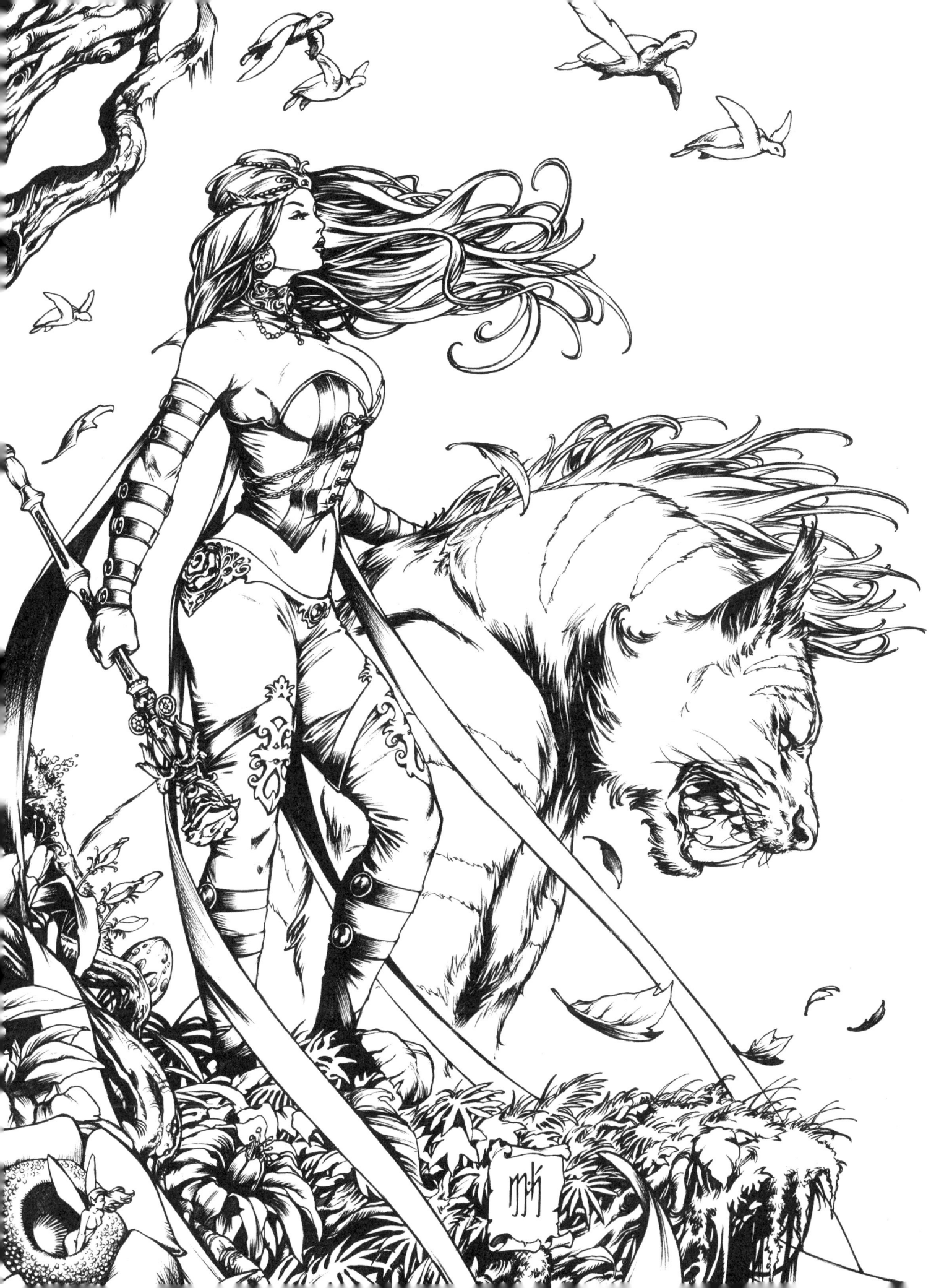

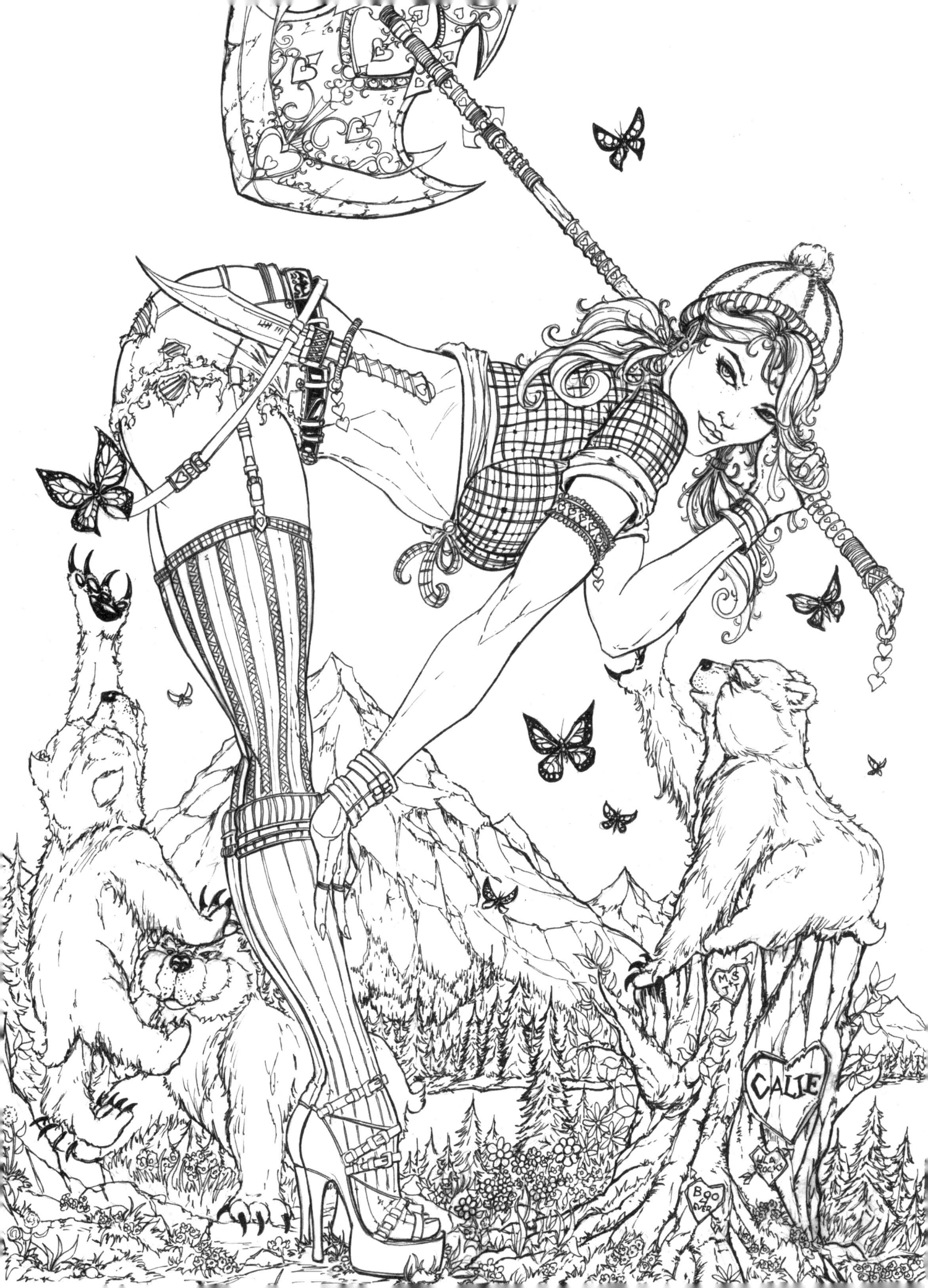

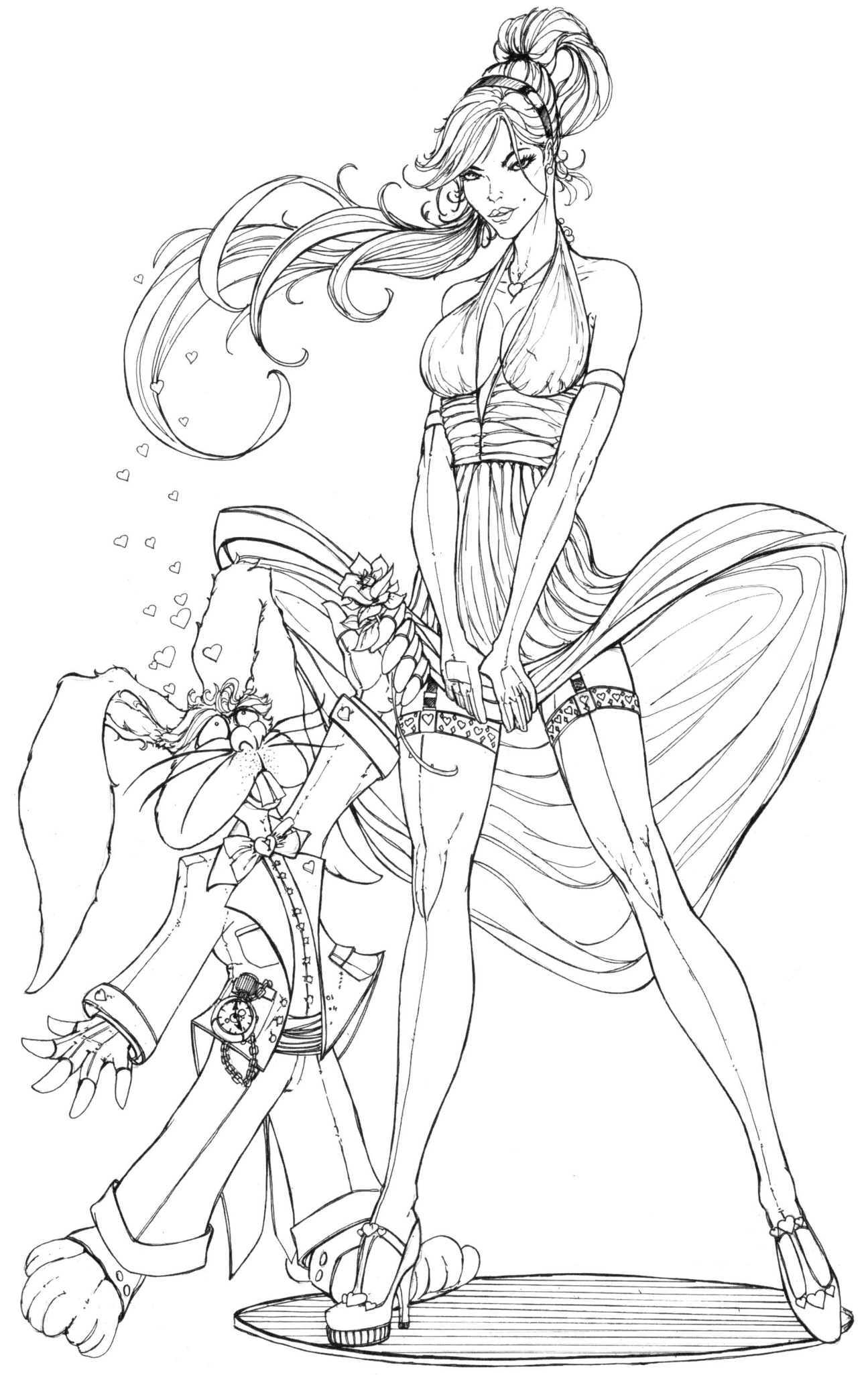

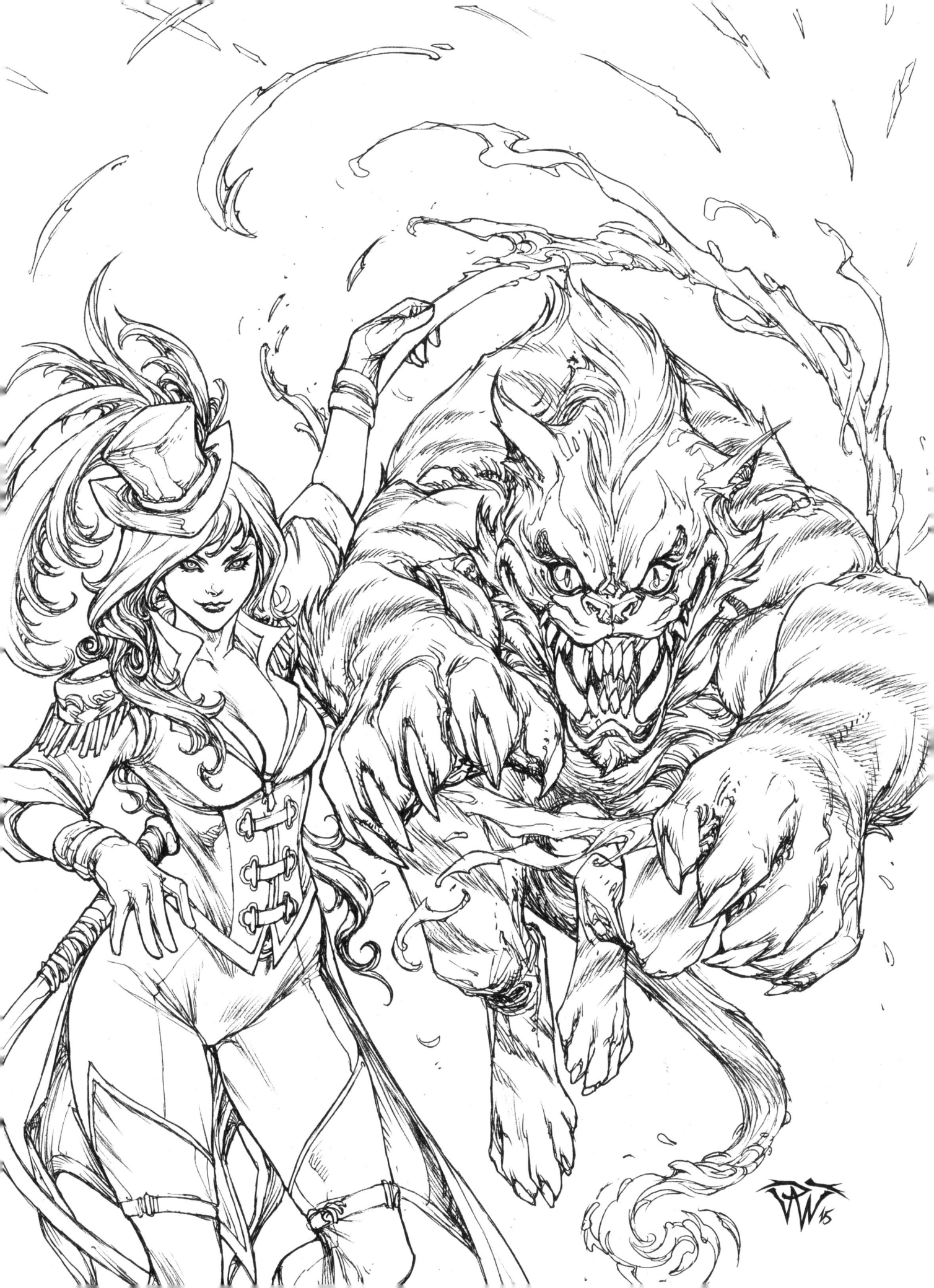

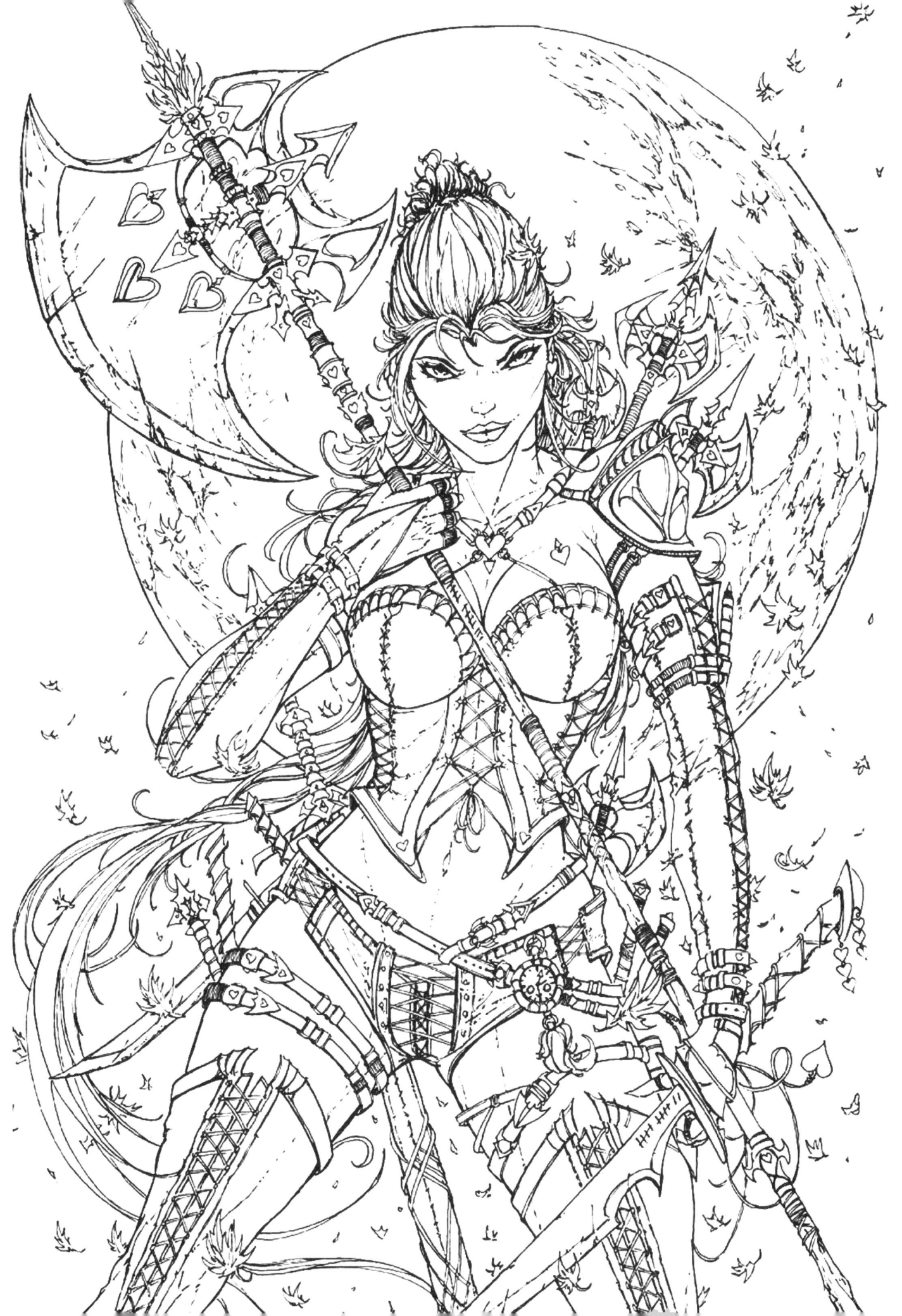

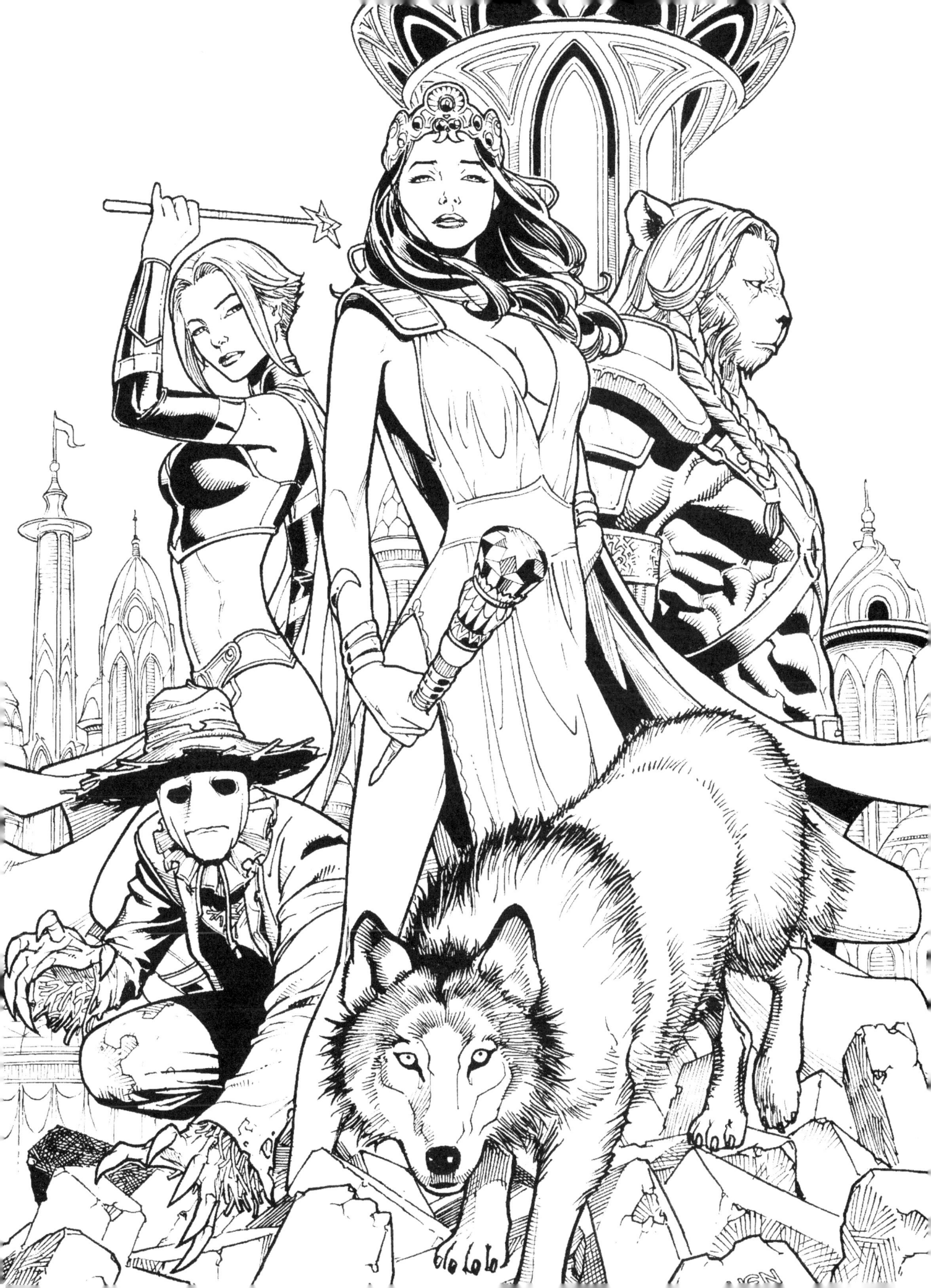

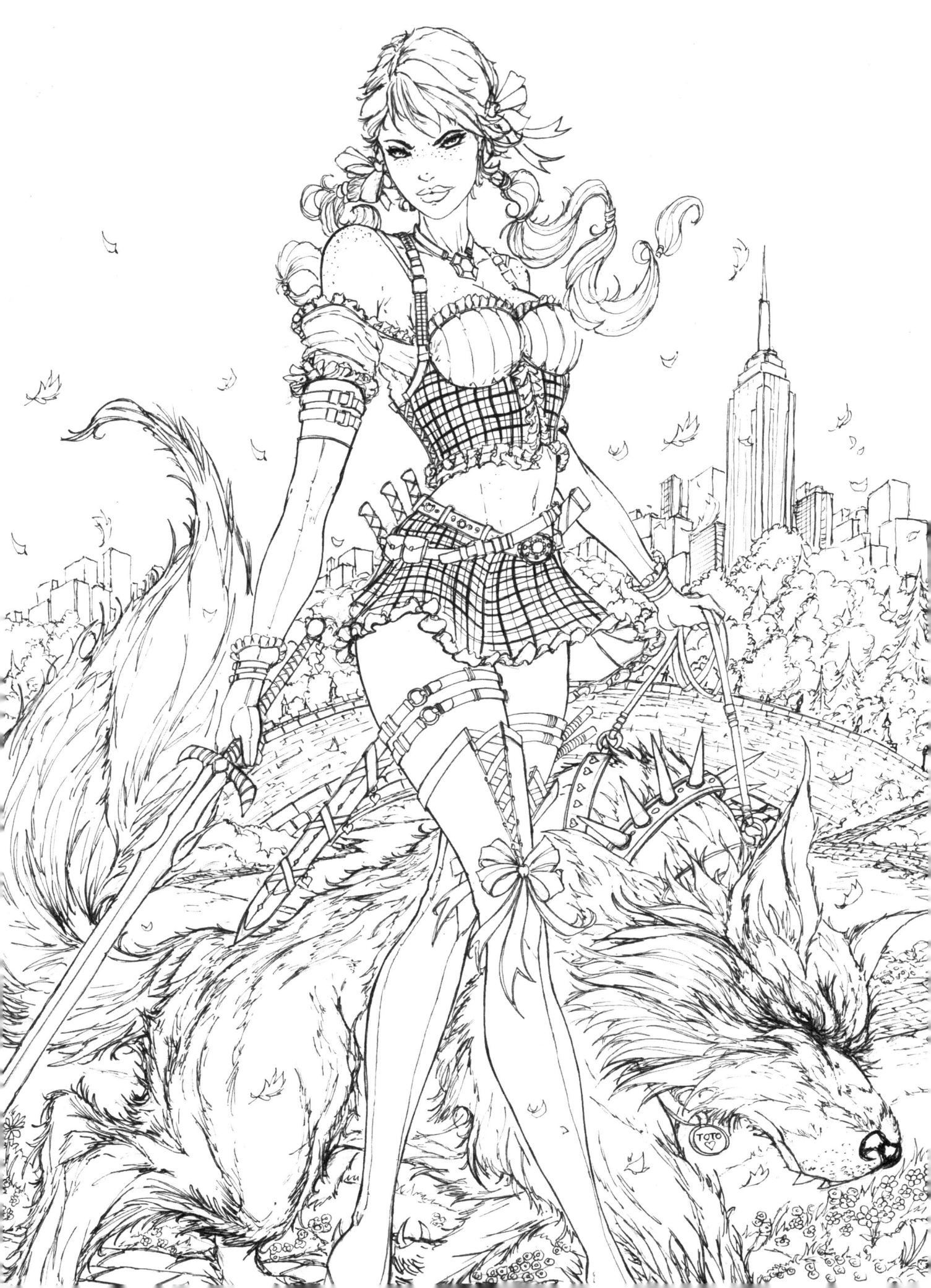

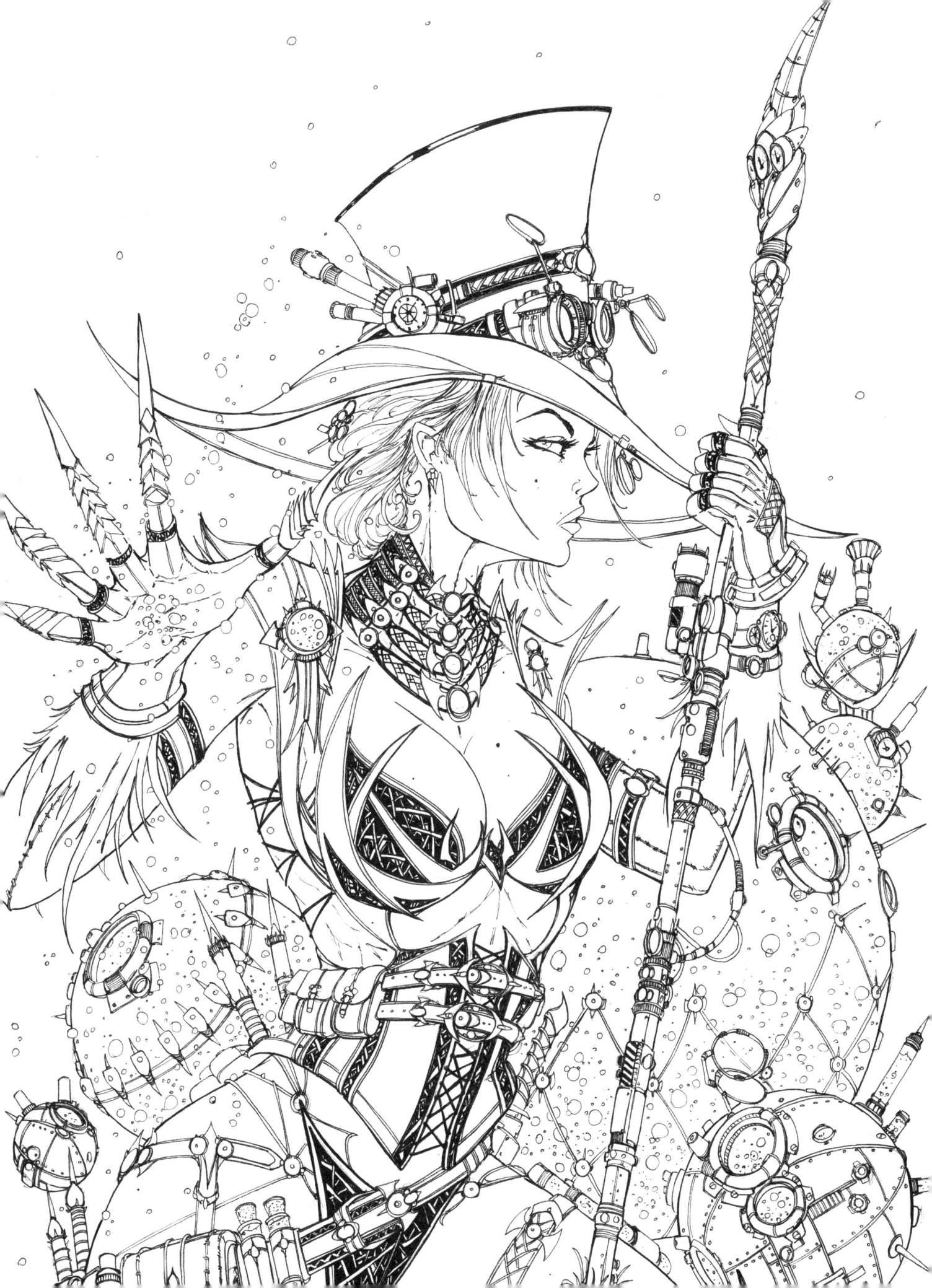

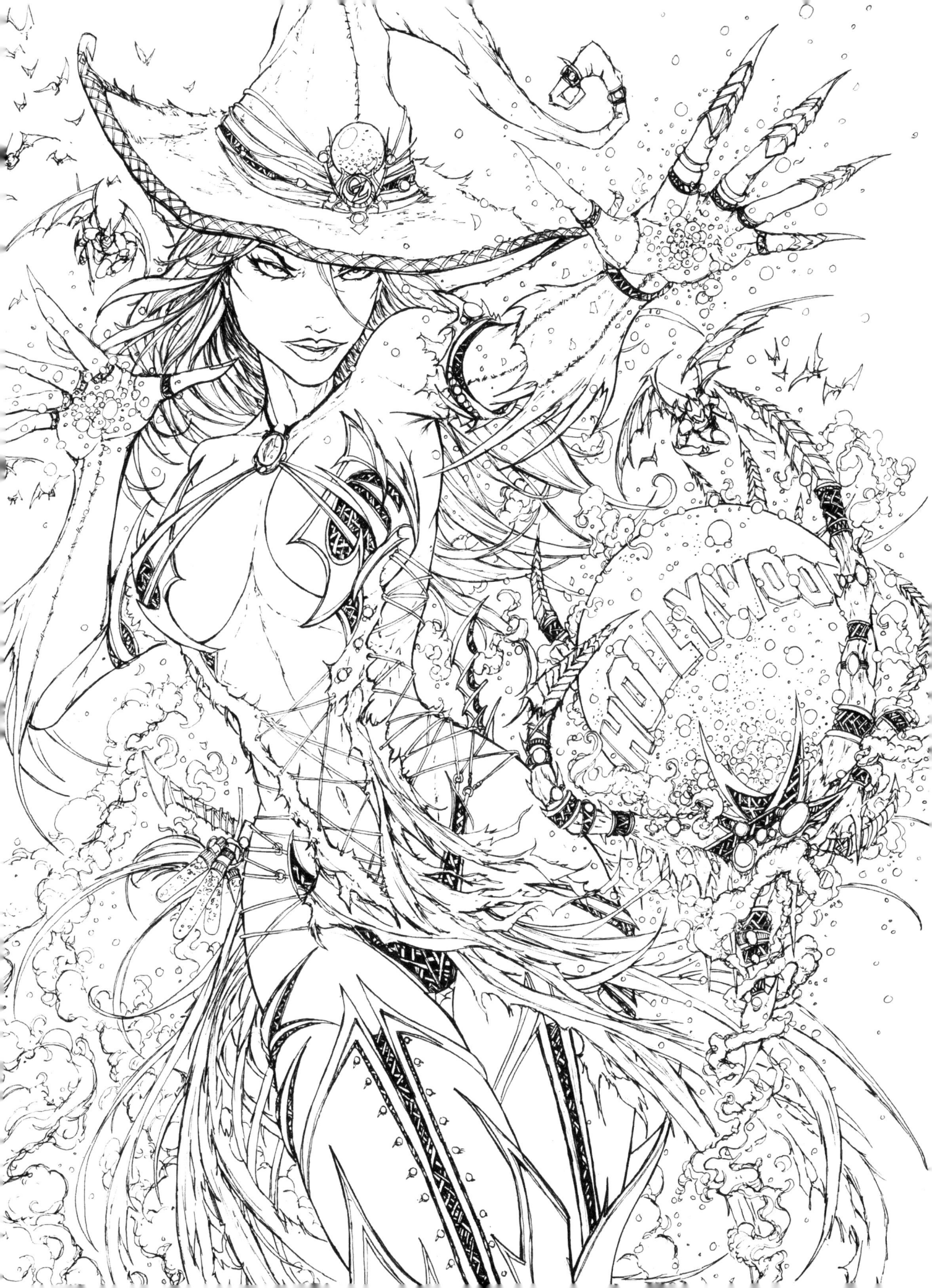

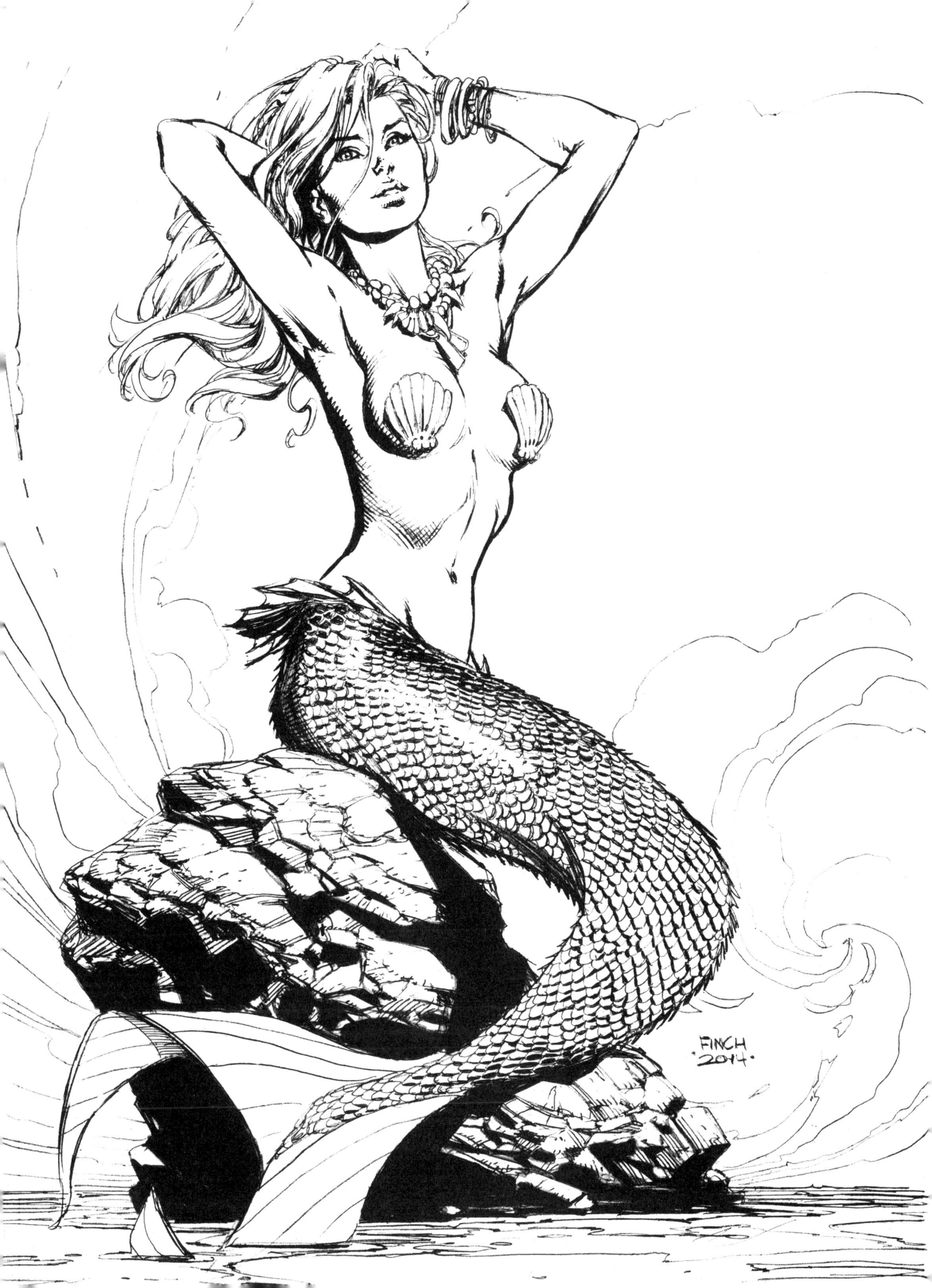

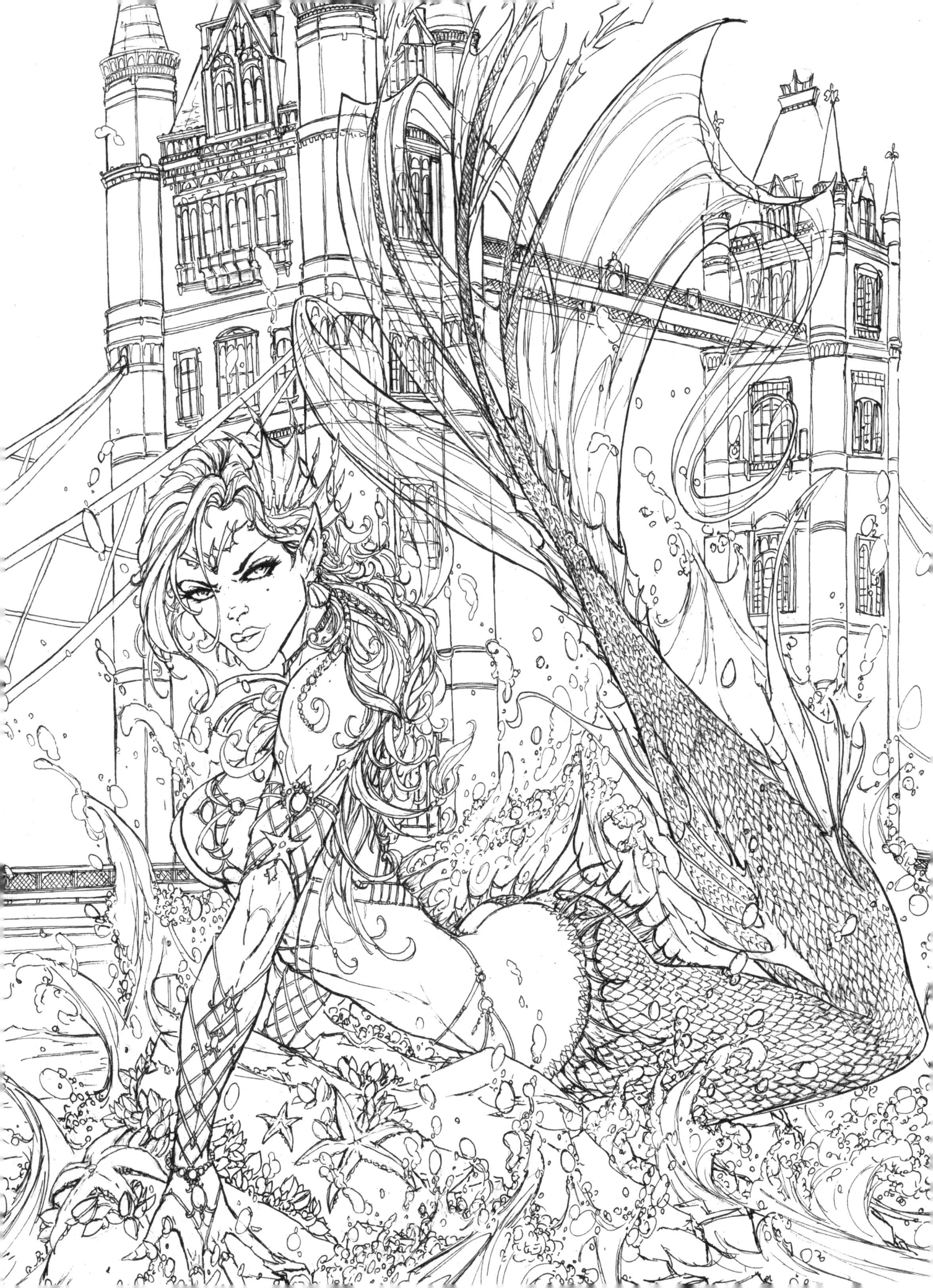

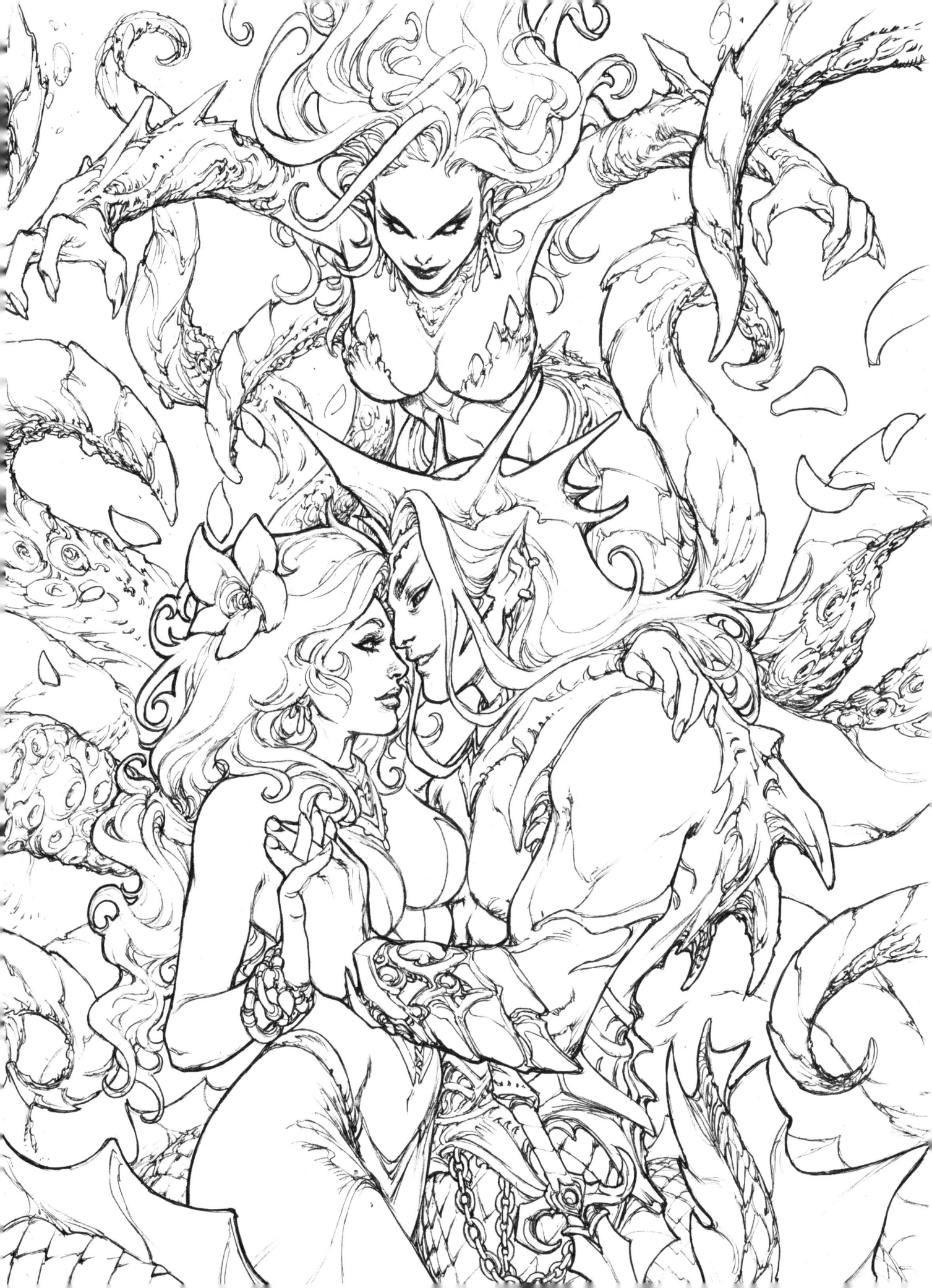

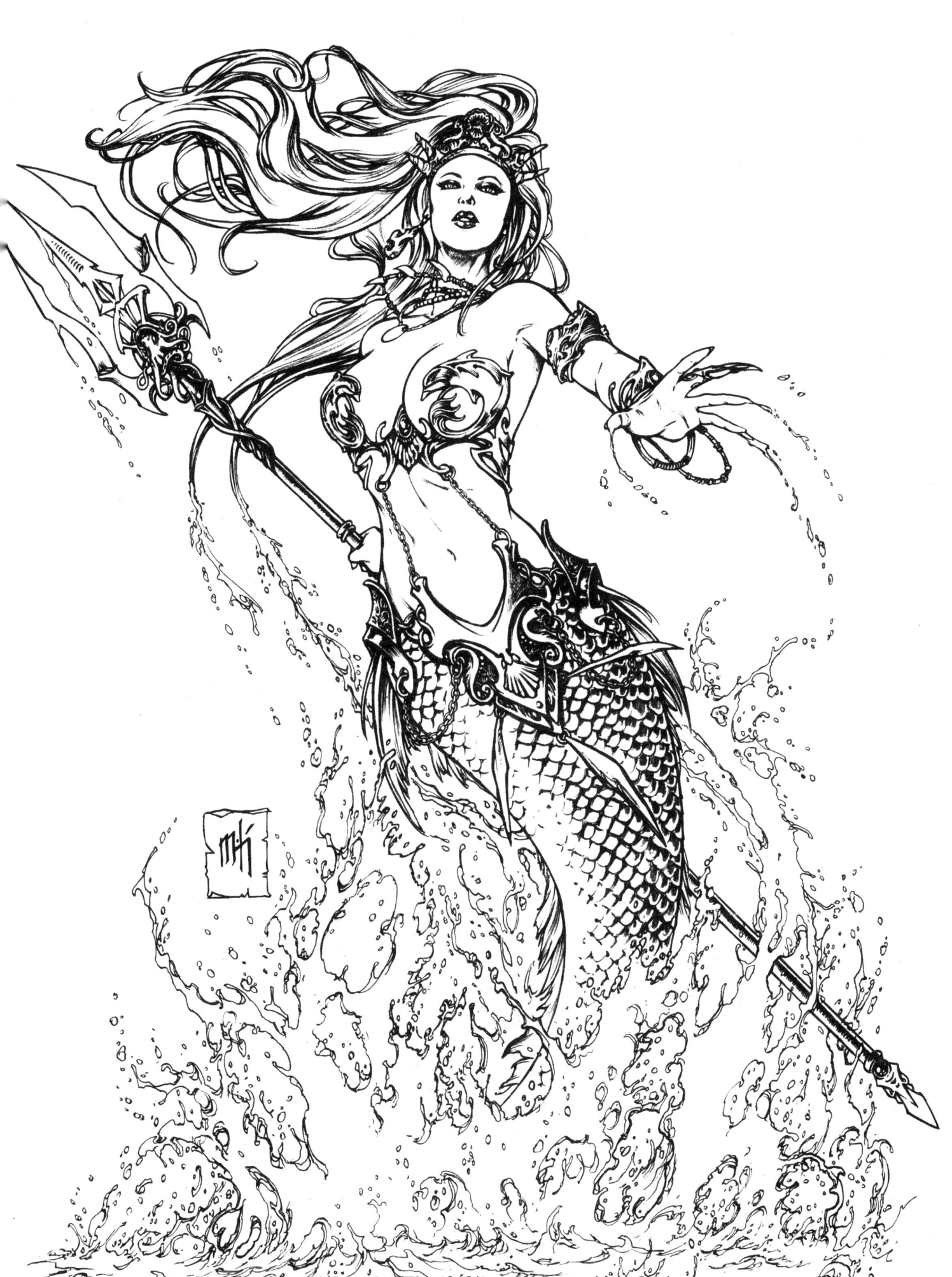

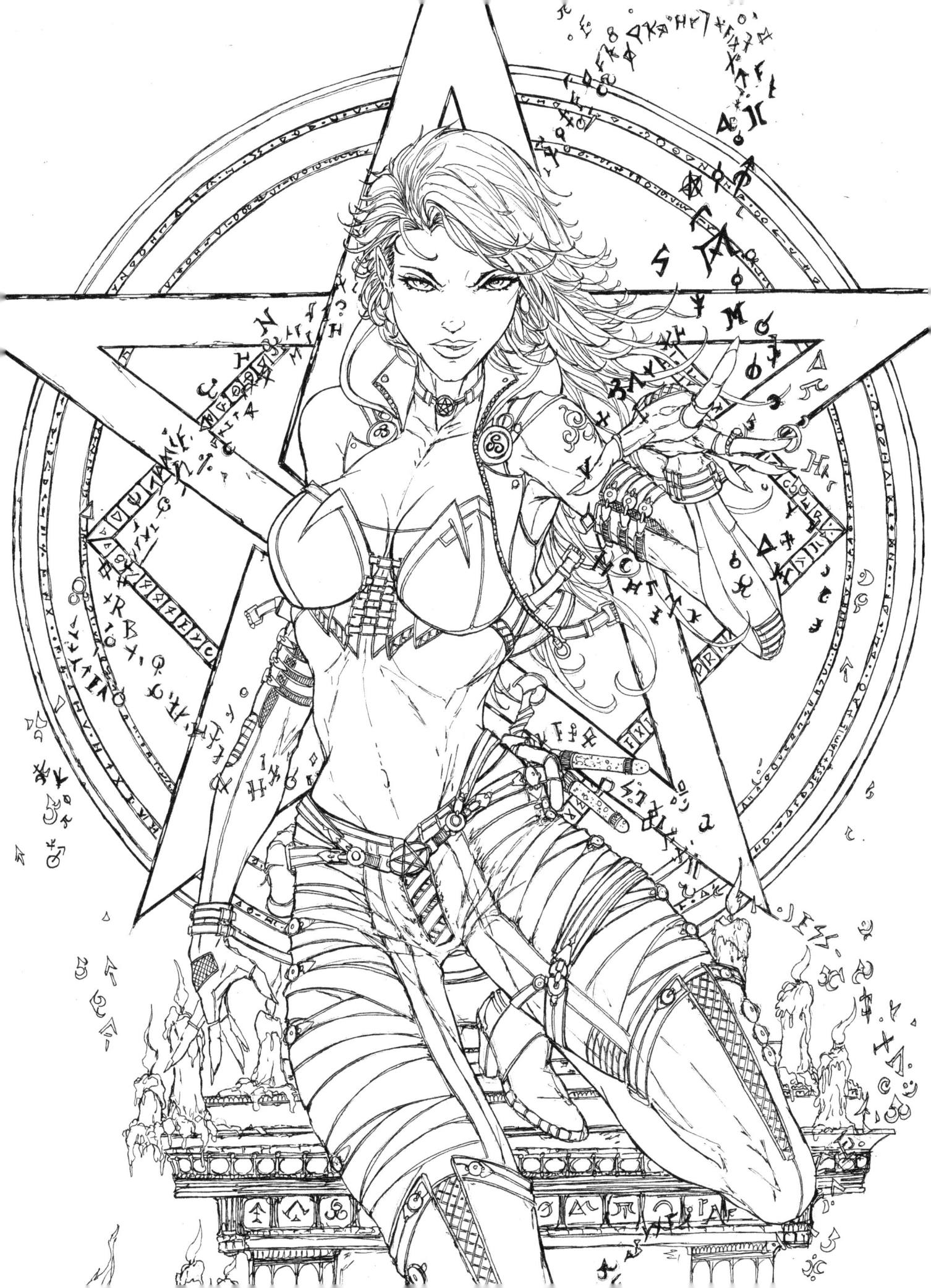

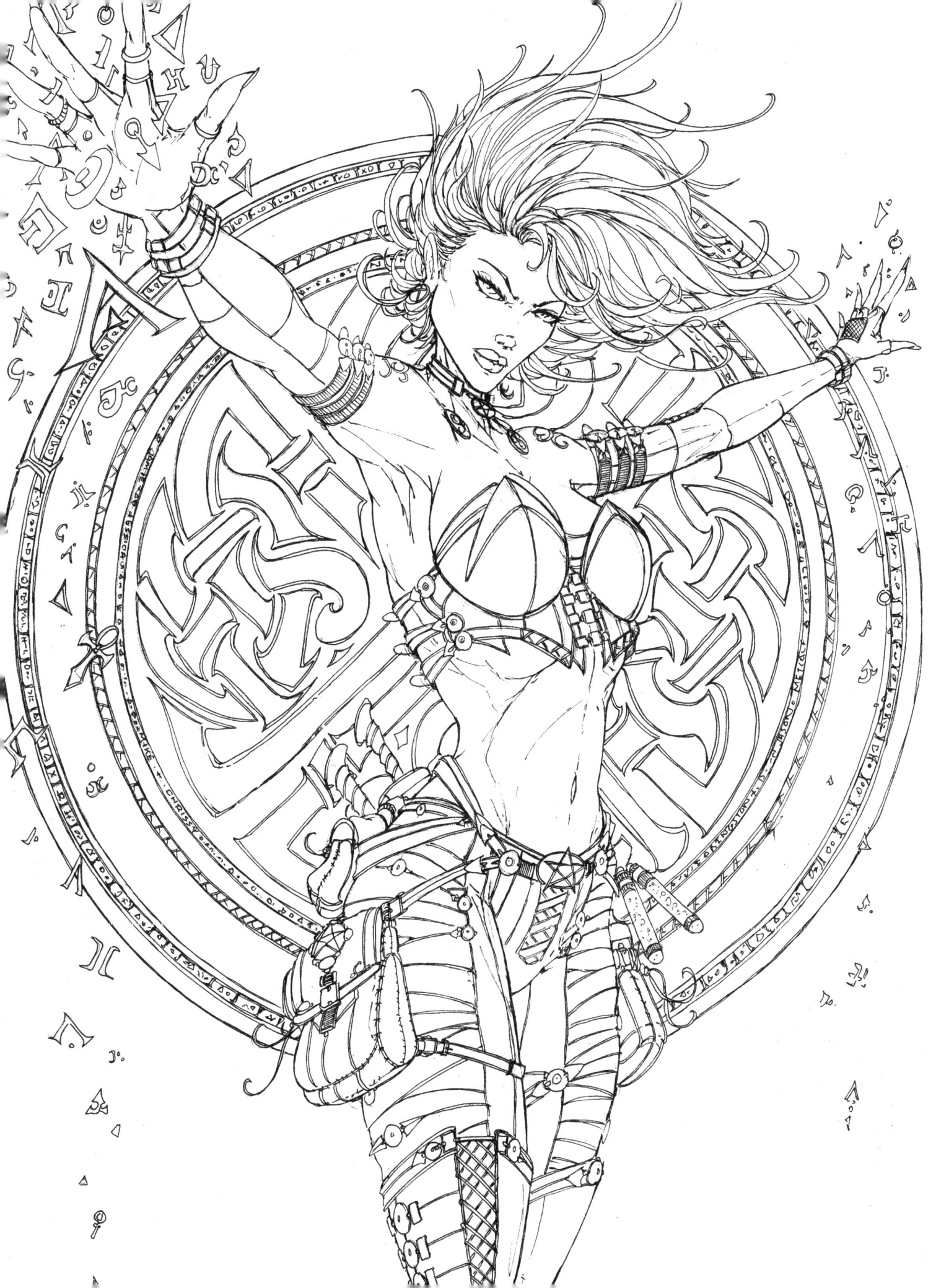

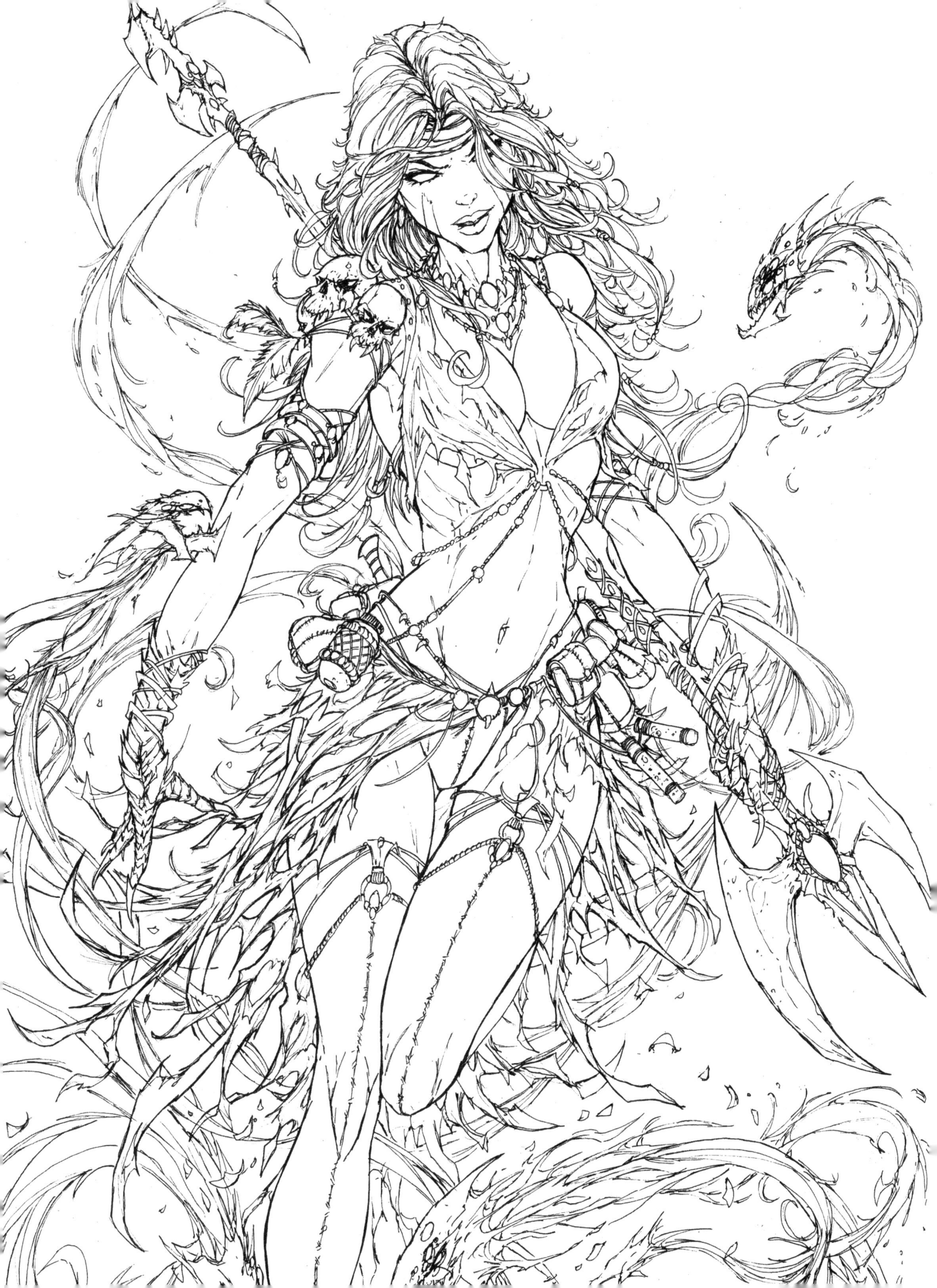

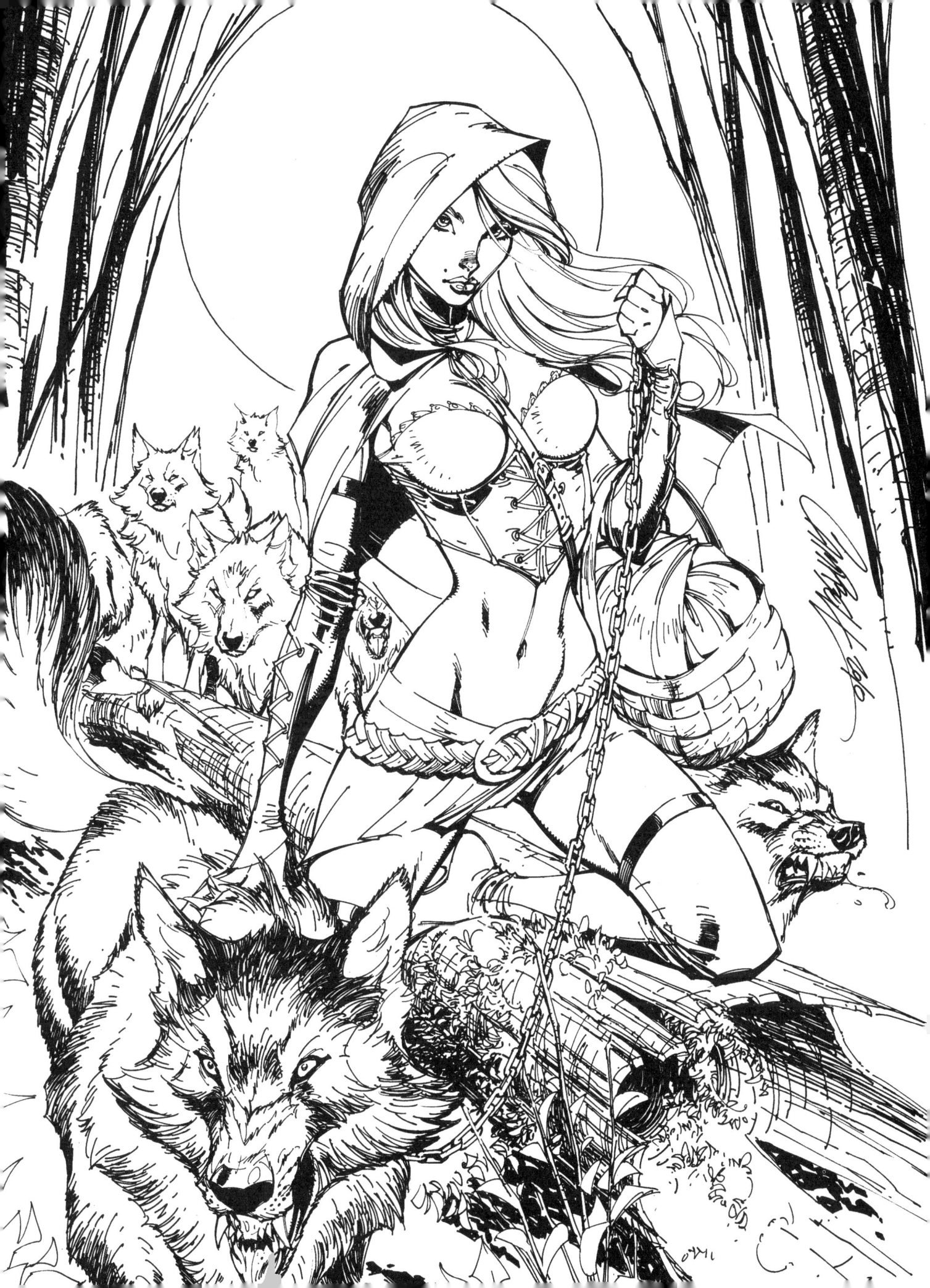

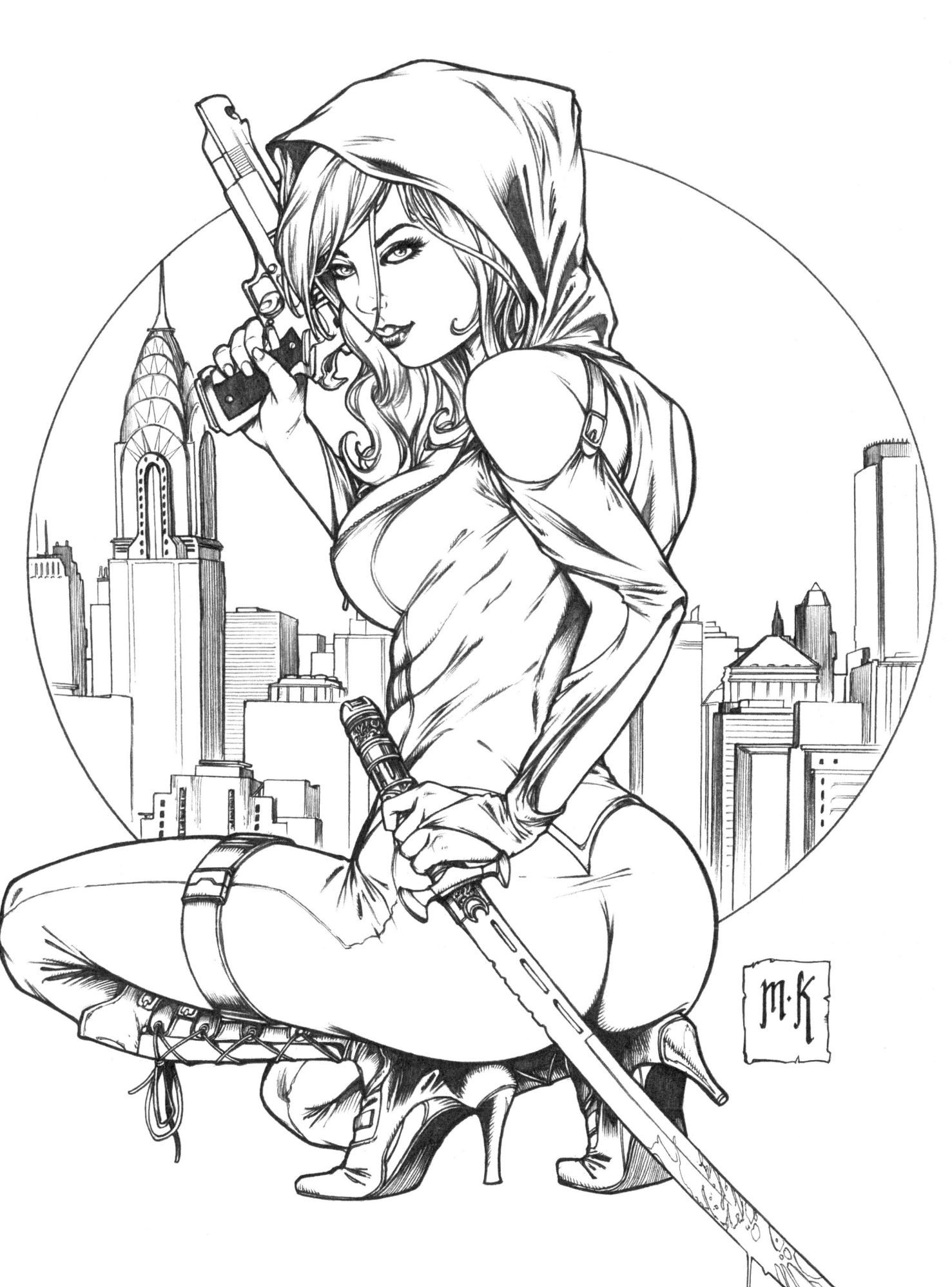

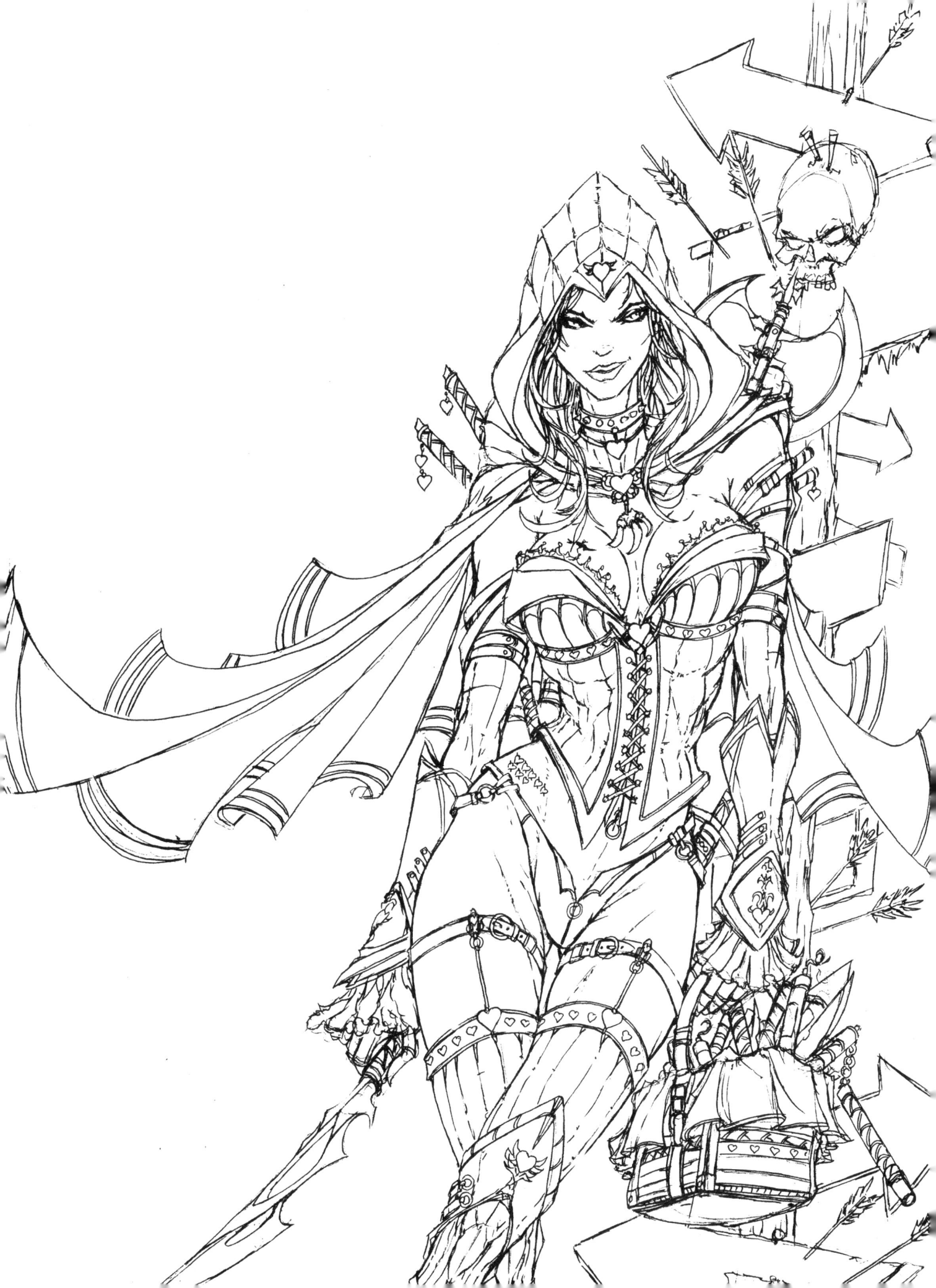

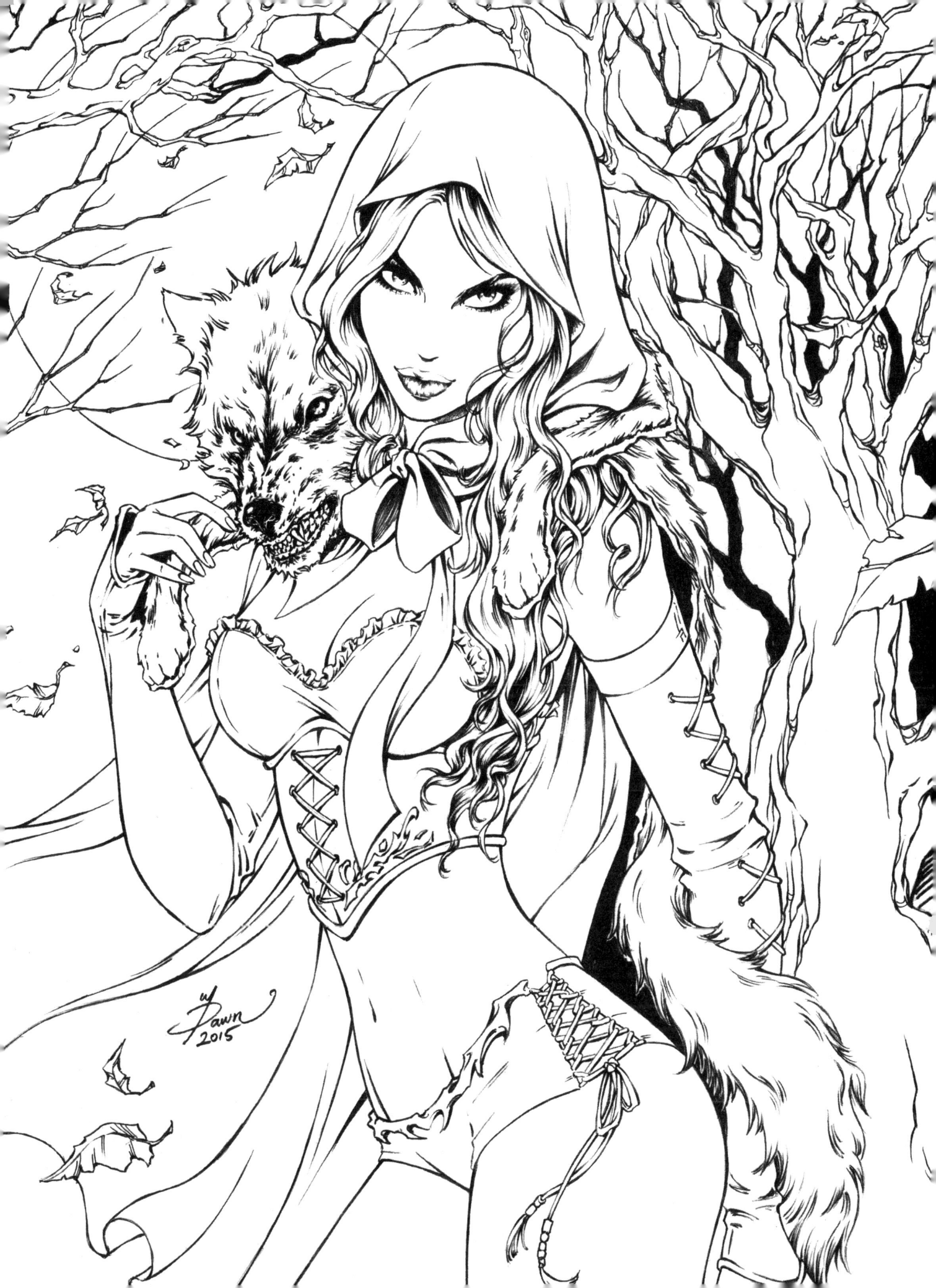

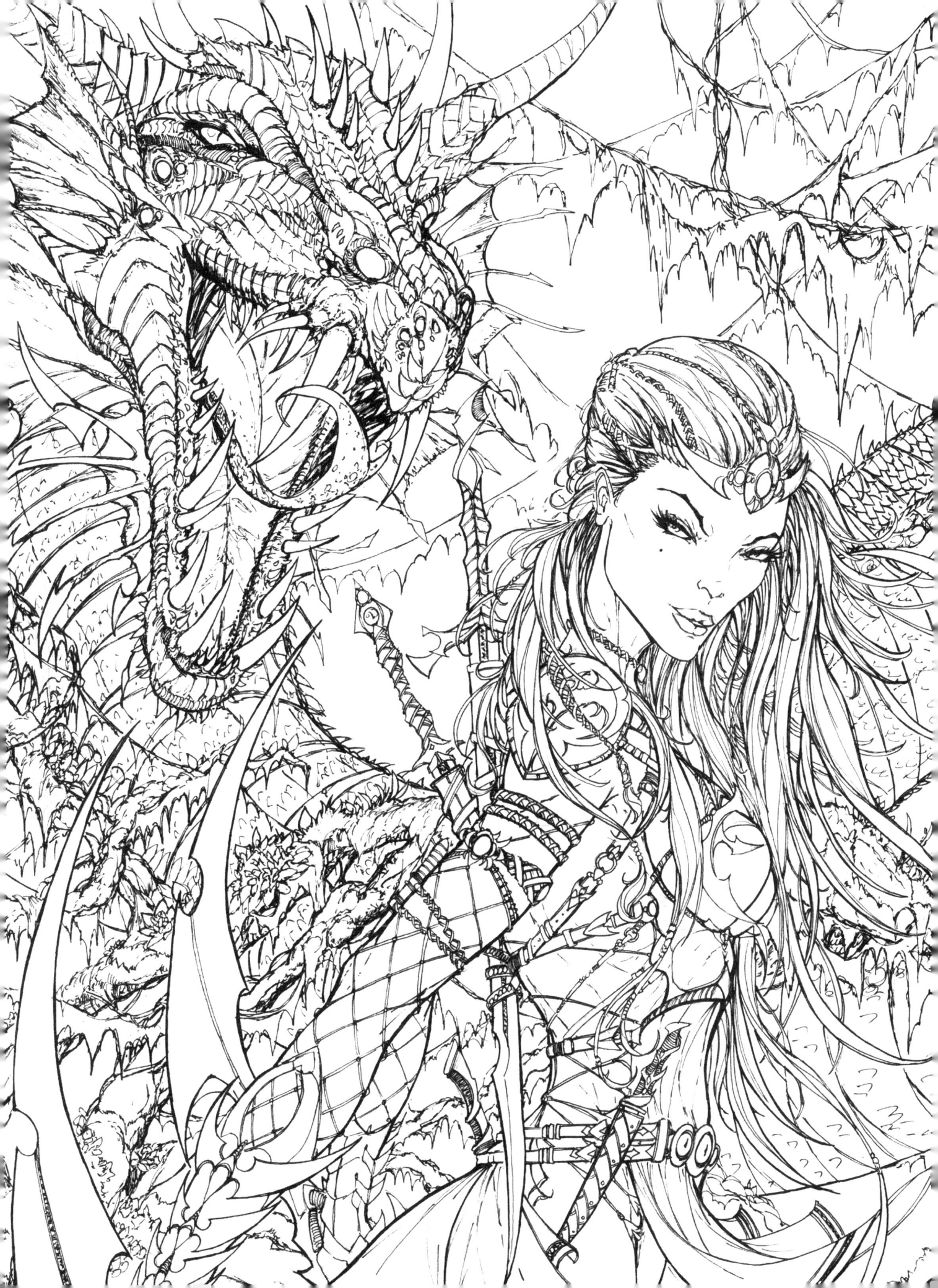

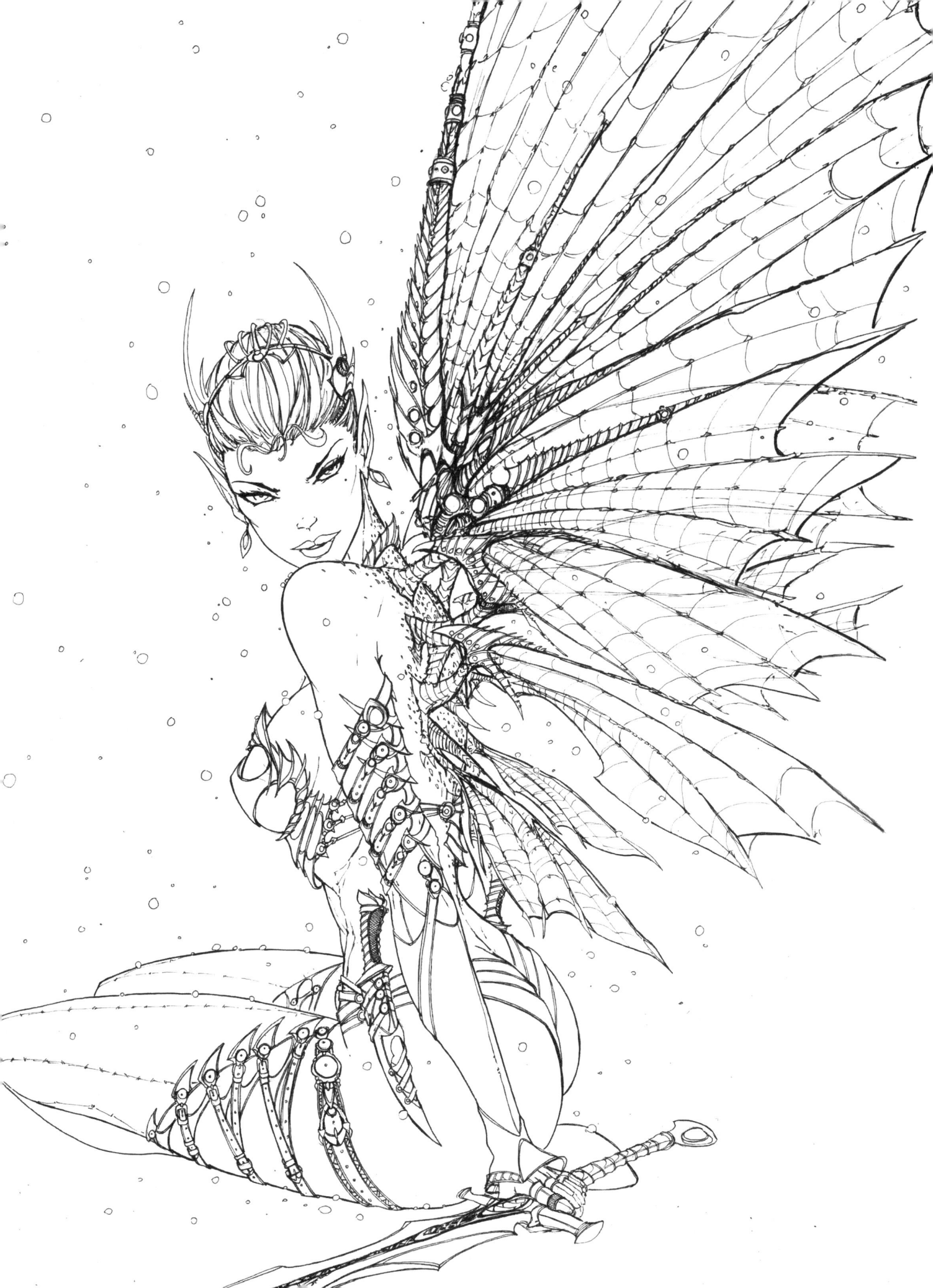

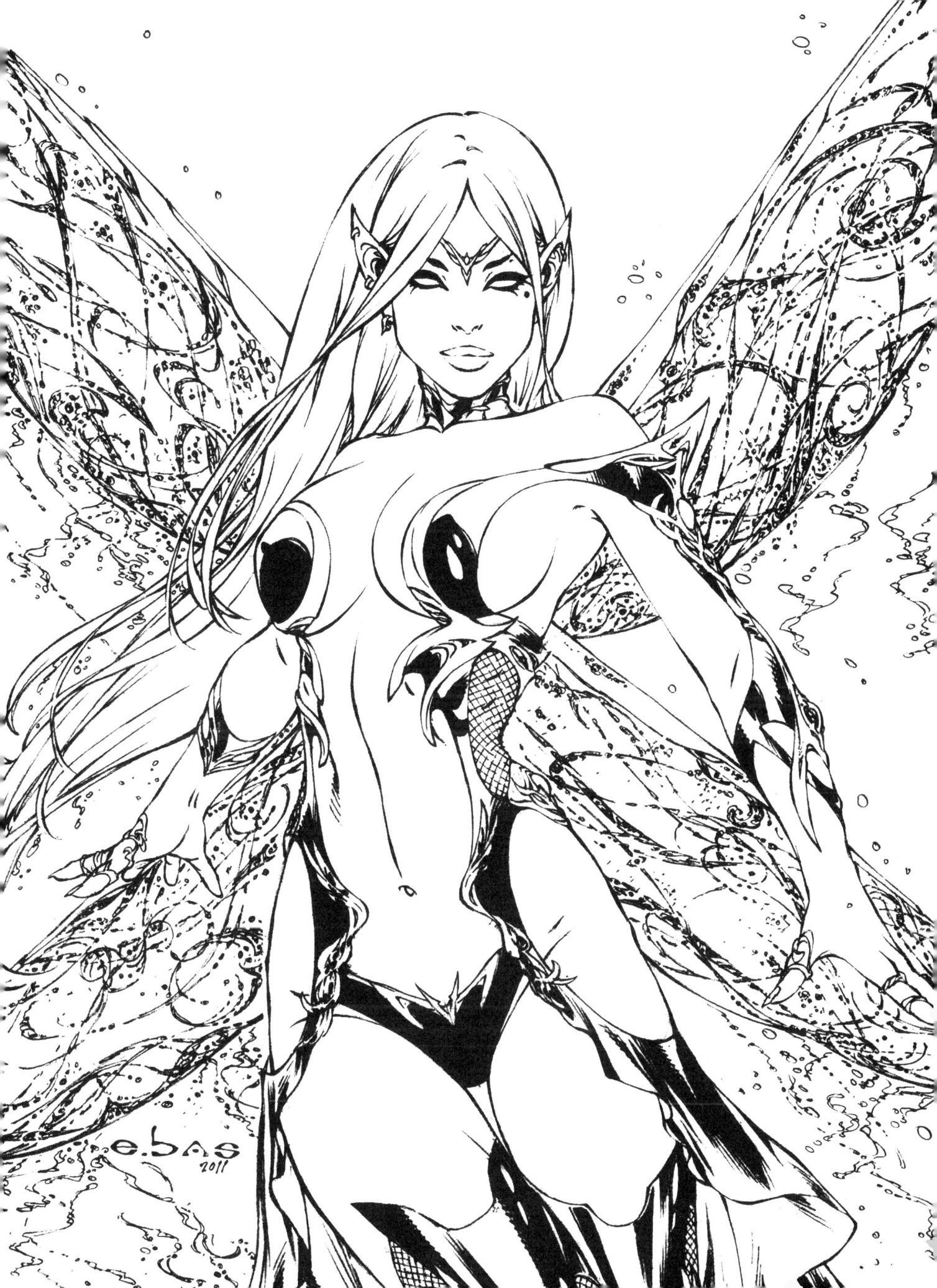

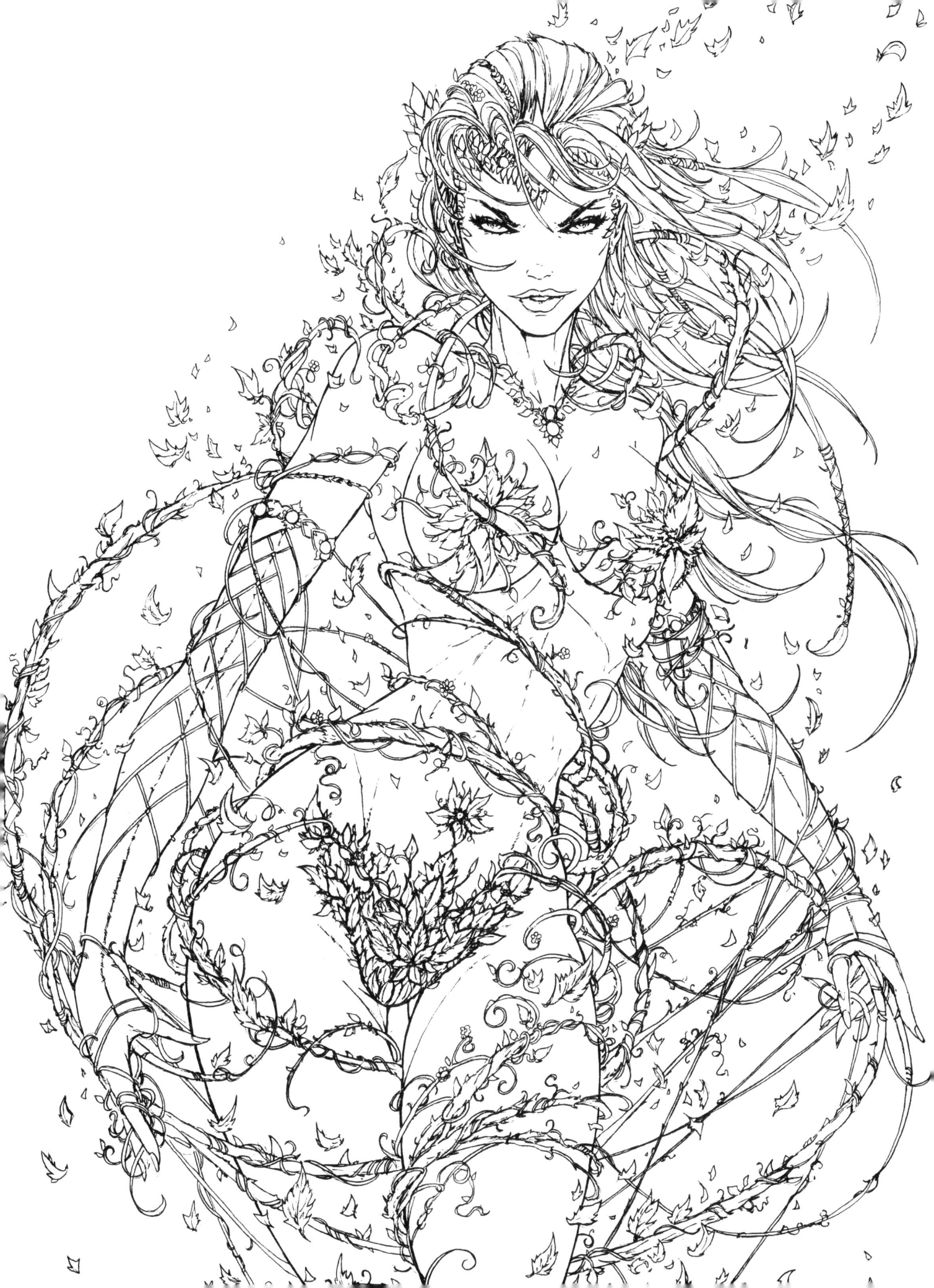

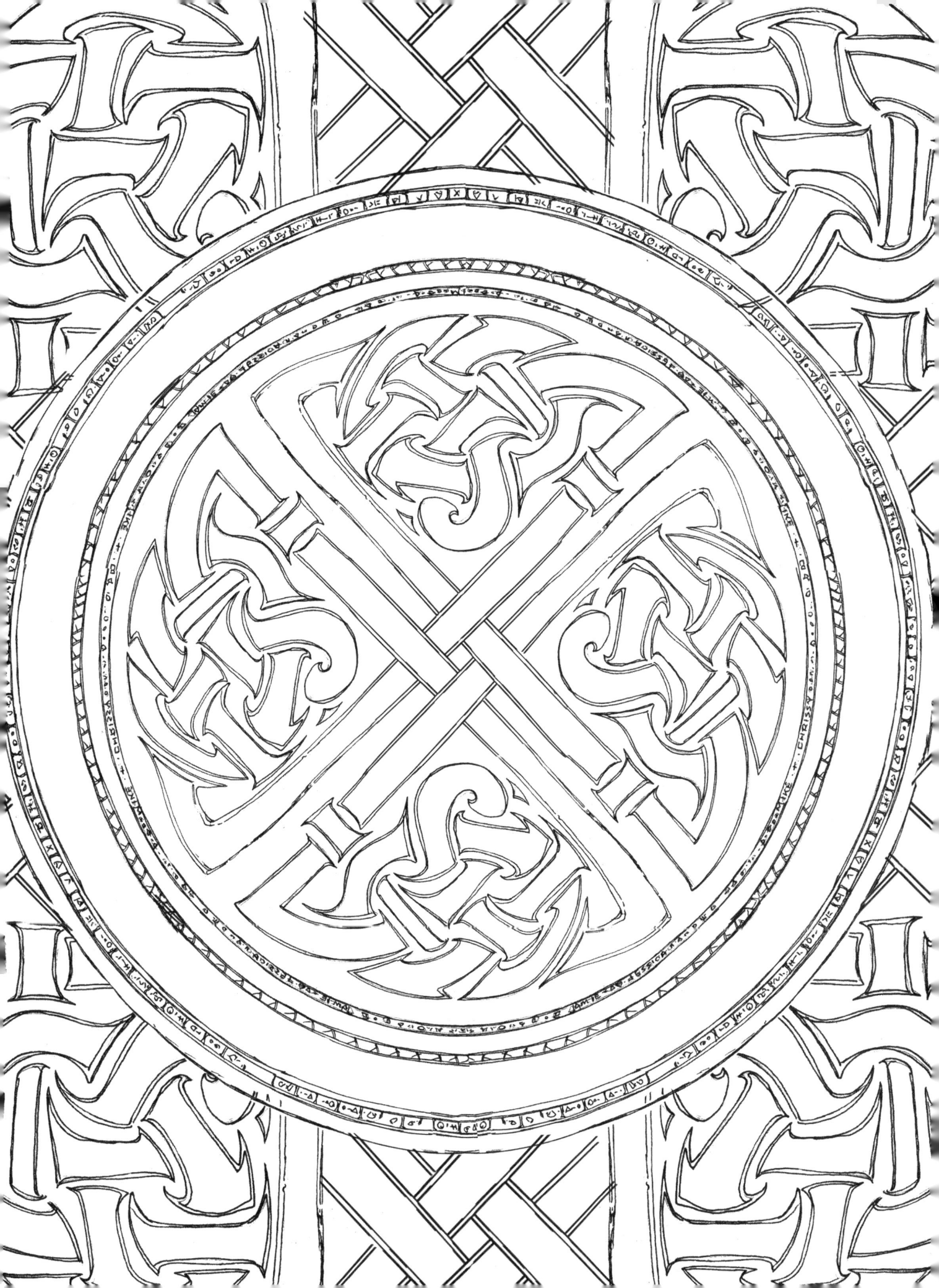

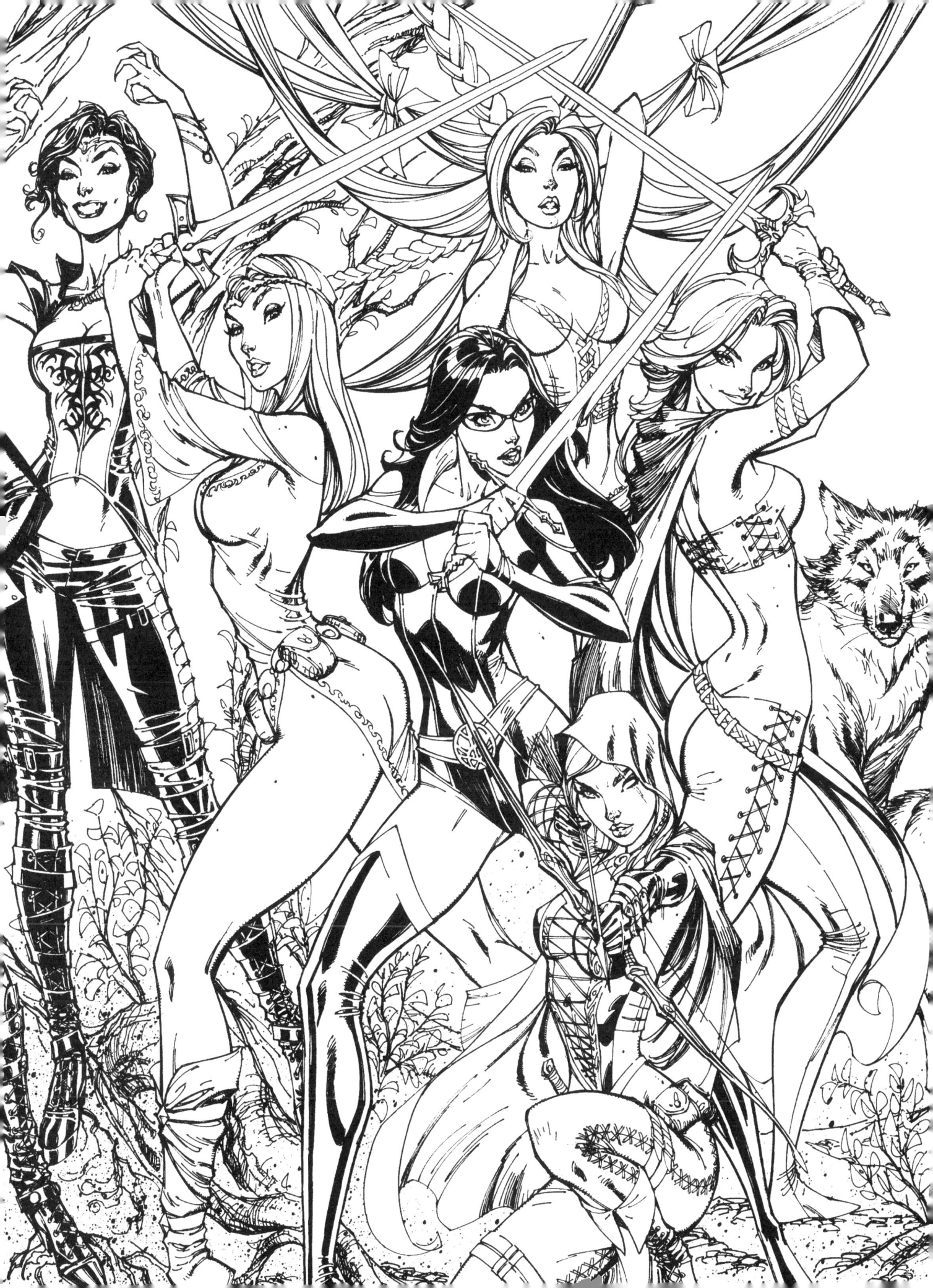

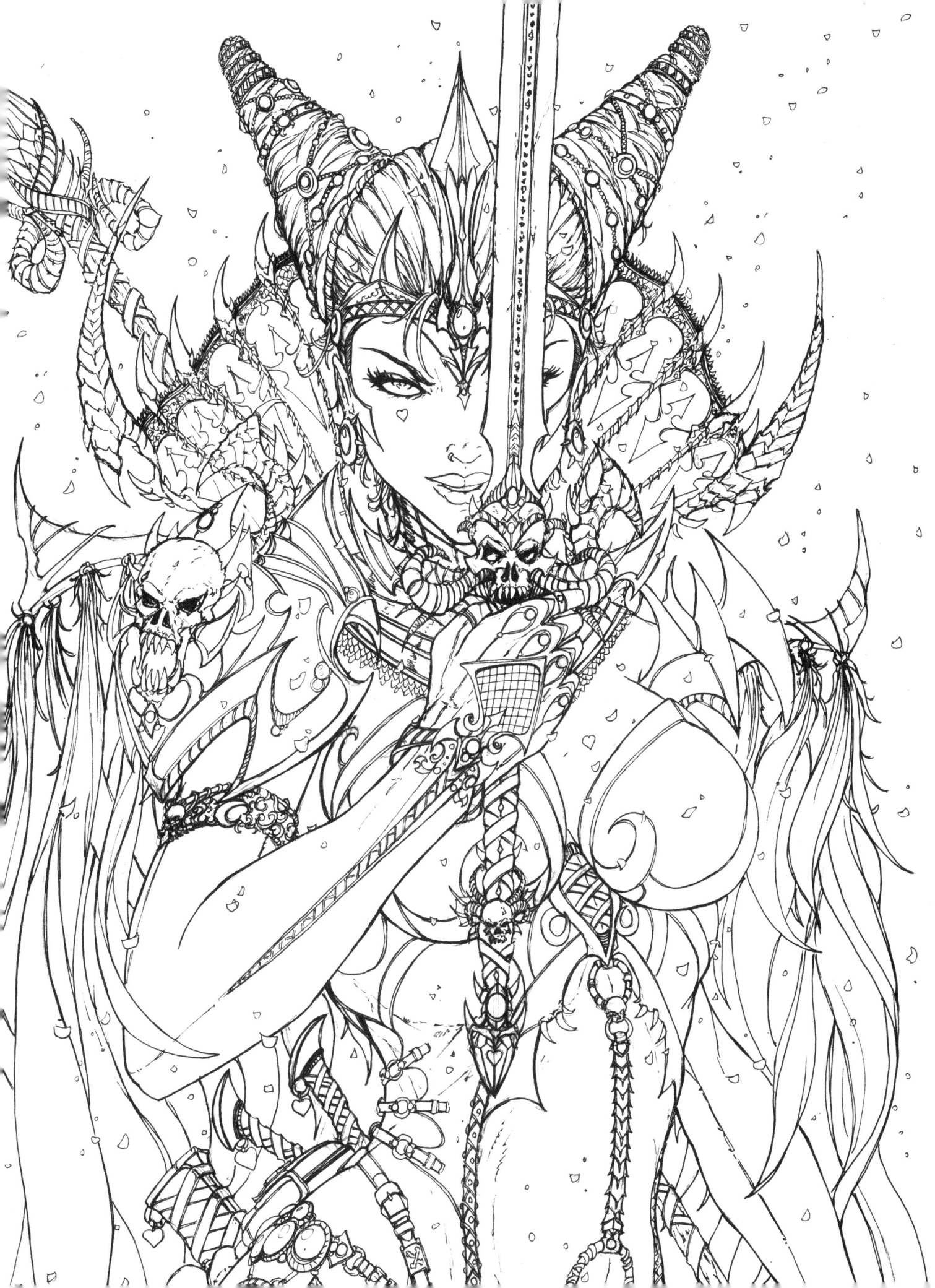

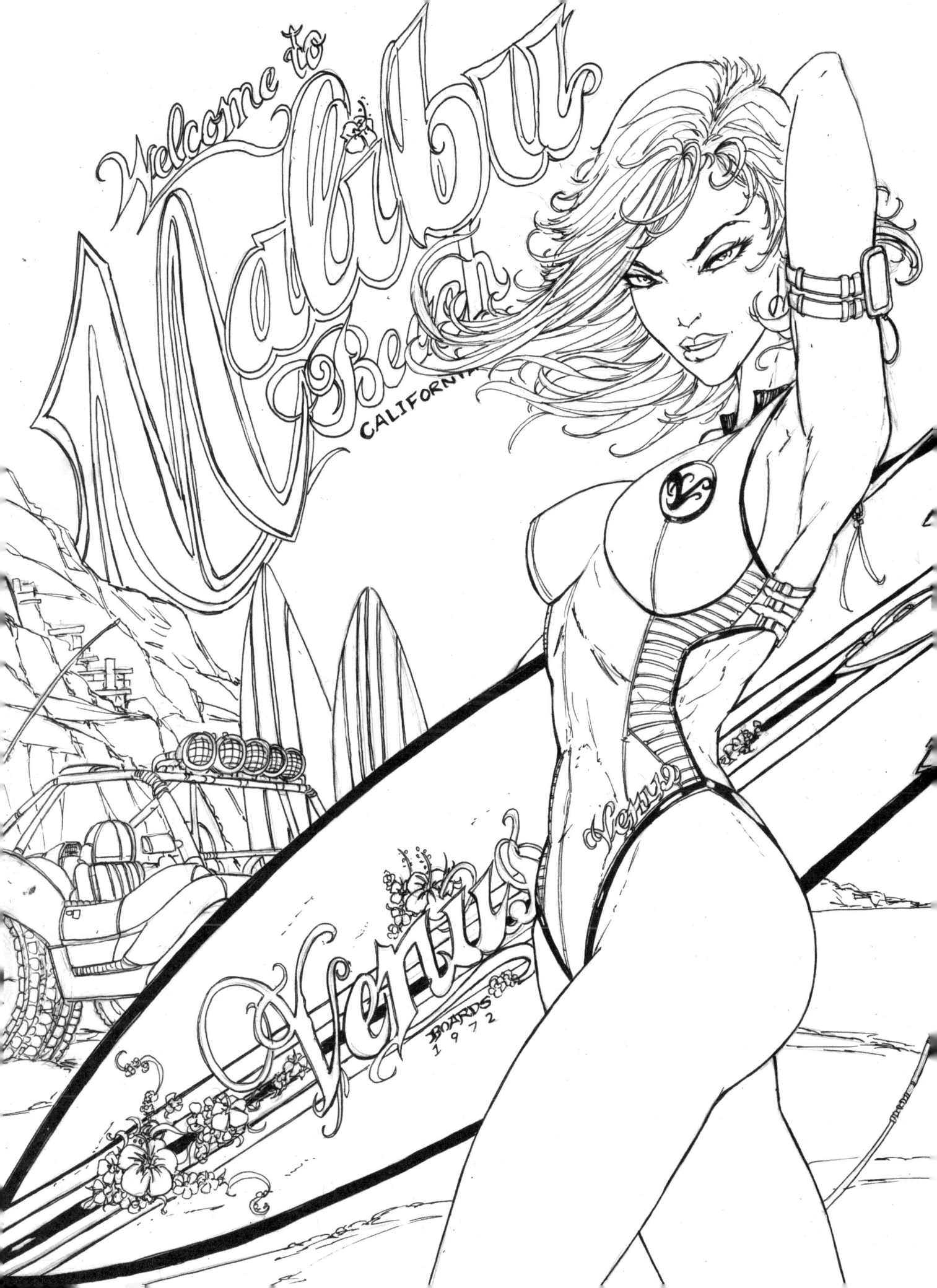

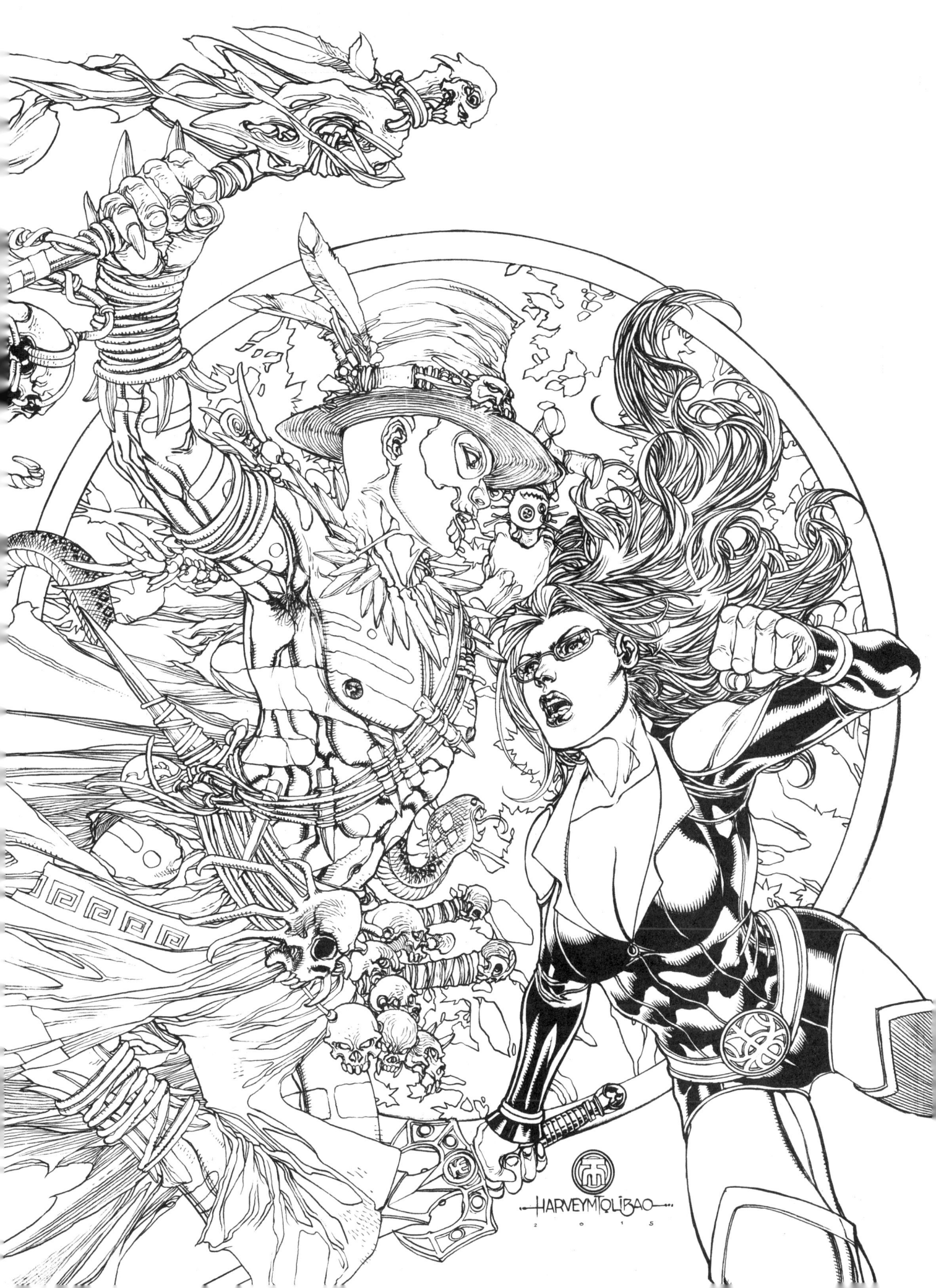

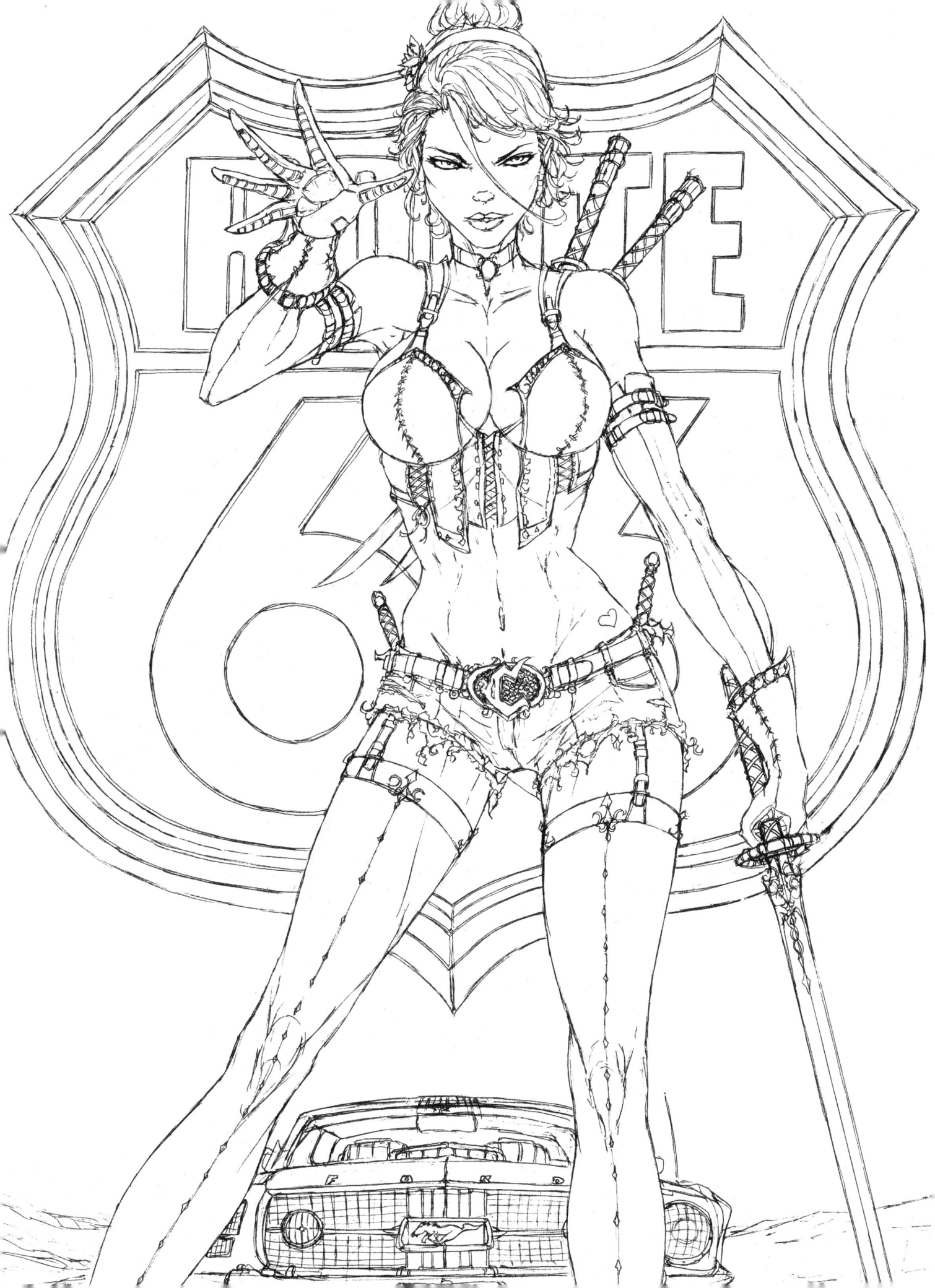

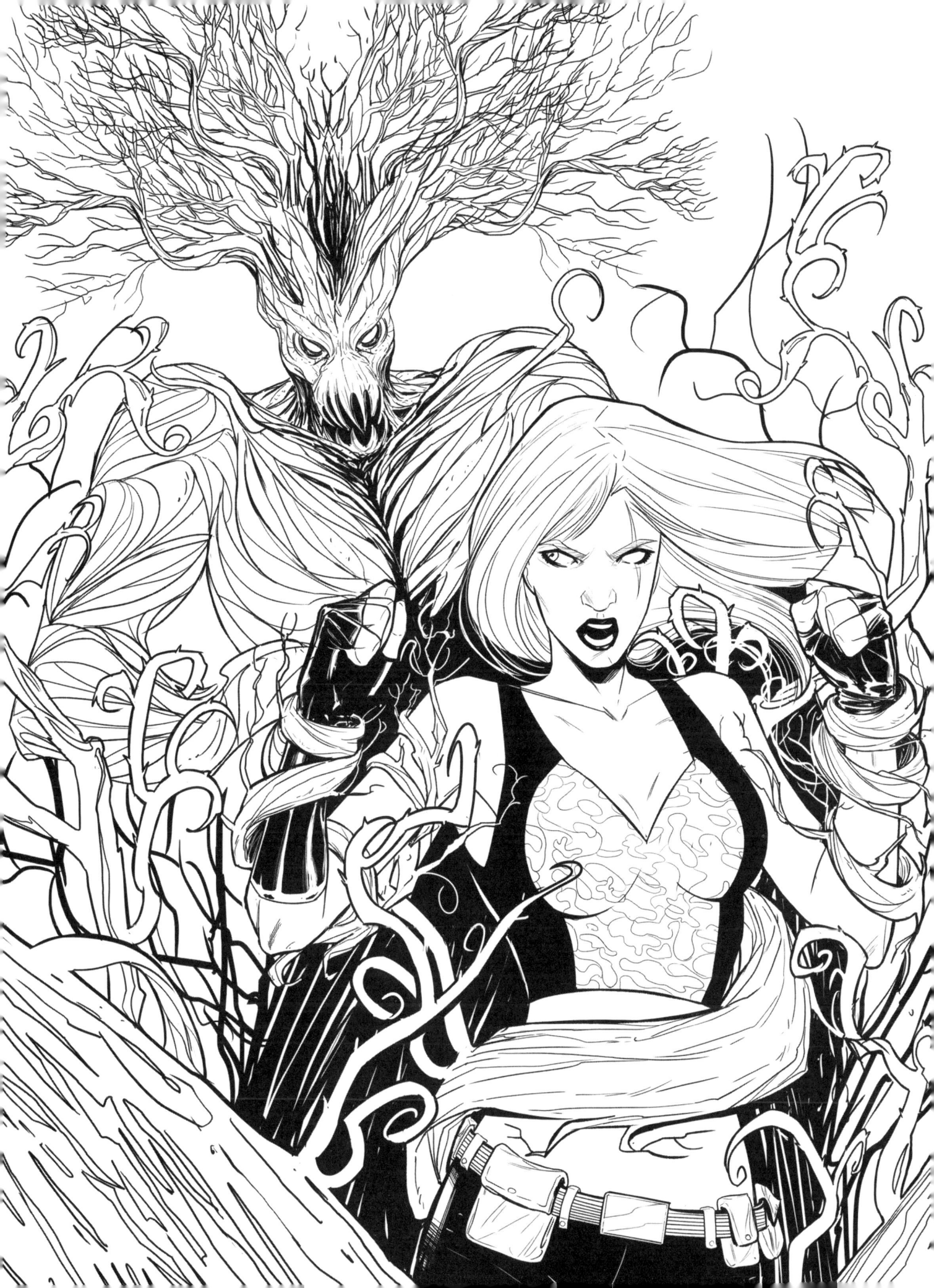

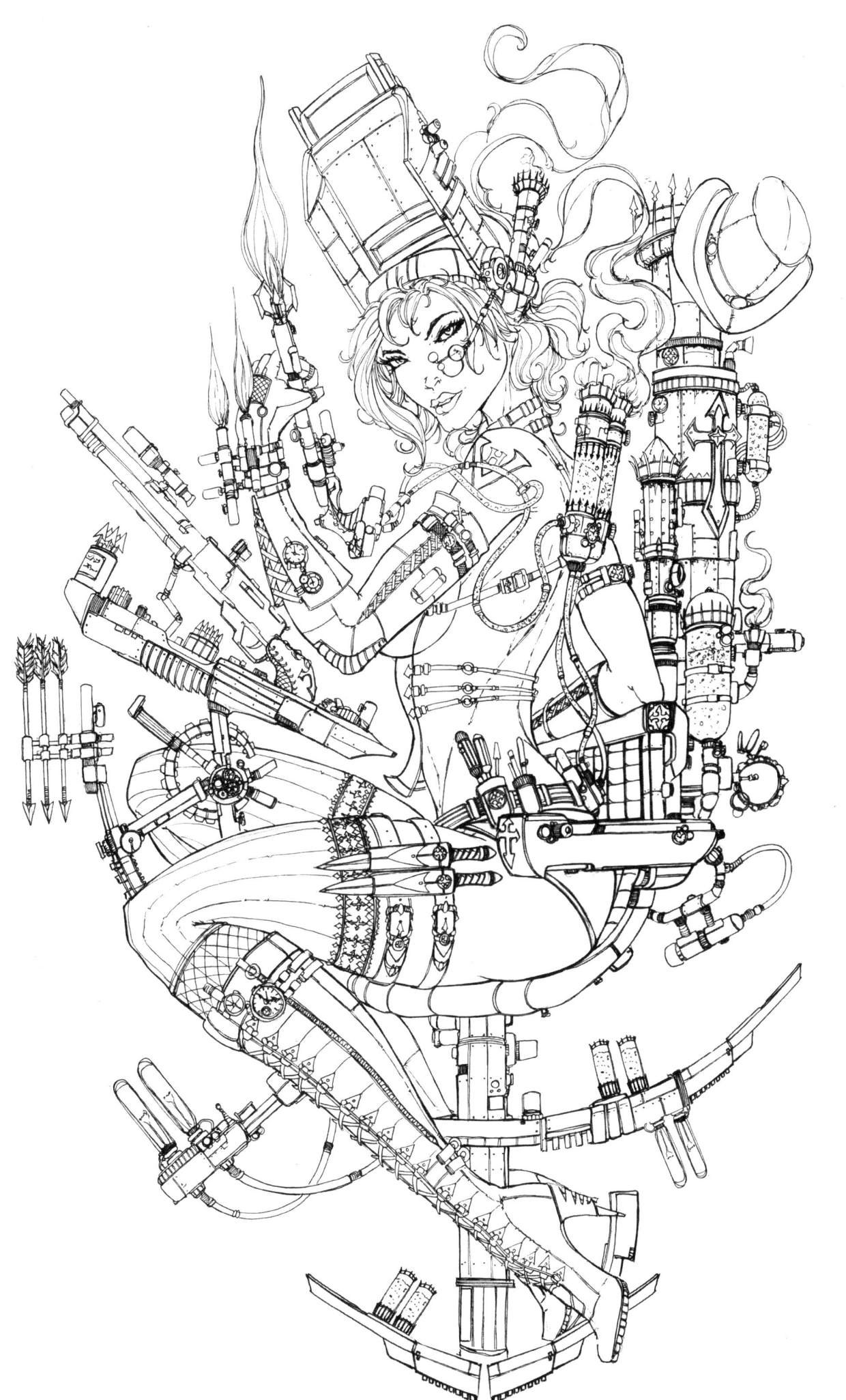

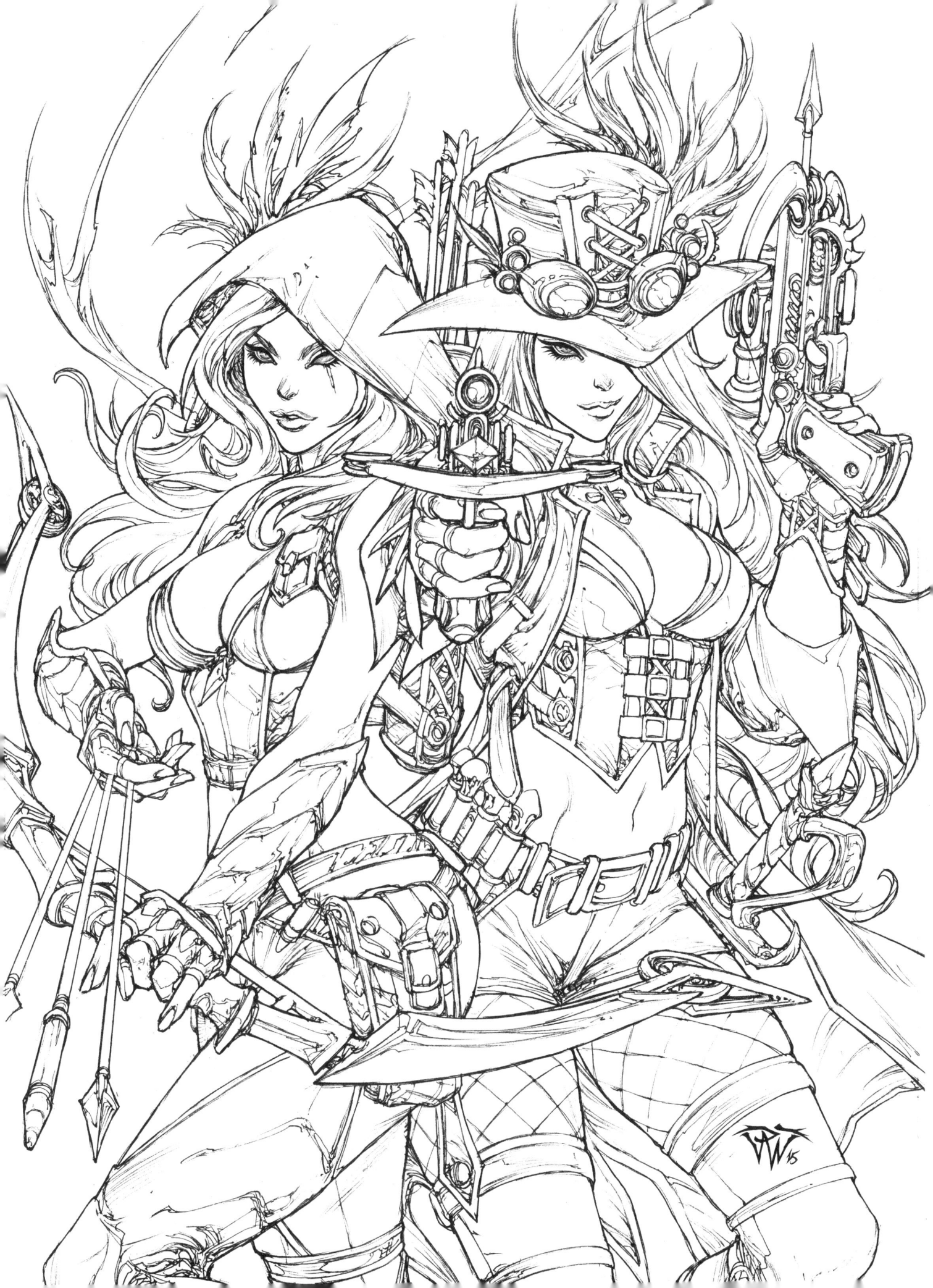

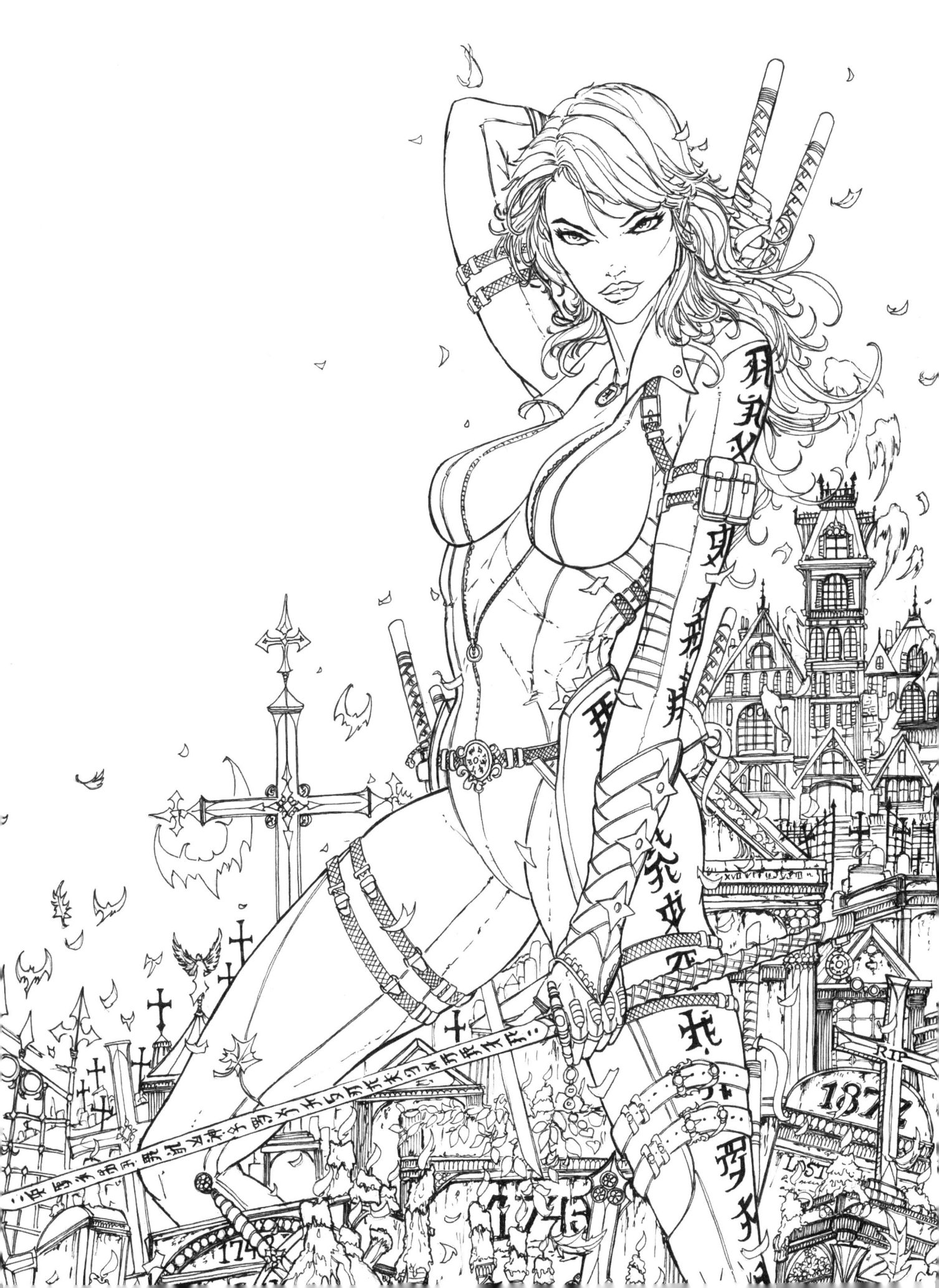

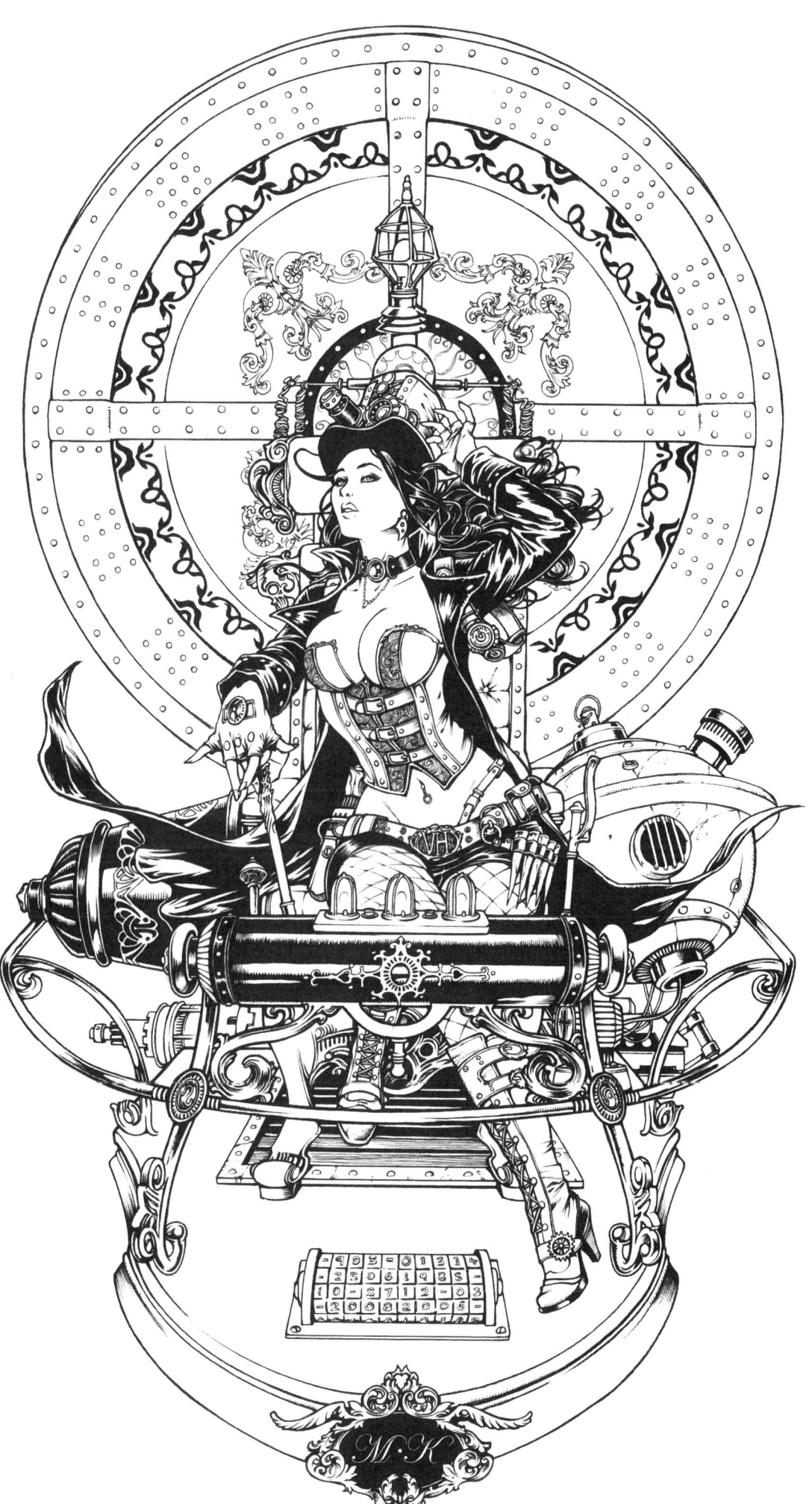